The
Woodcut Artist's
HANDBOOK

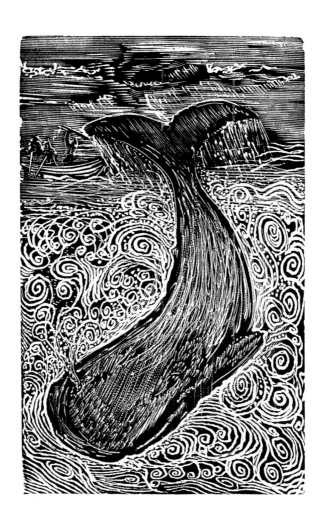

The
Woodcut Artist's
HANDBOOK

Techniques and Tools for Relief Printmaking

Second Edition, updated and expanded

GEORGE A. WALKER

FIREFLY BOOKS

A FIREFLY BOOK

Published by Firefly Books Ltd. 2010

Second Edition, First Printing

Publisher Cataloging-in-Publication Data (U.S.)

Walker, George A. (George Alexander), 1960-
 The woodcut artist's handbook : techniques and tools for relief printmaking / George A. Walker.
[] p. : ill. (some col.) ; cm.
Includes bibliographical references and index.
Summary: Instructional book on the art of creating woodcuts. Includes a detailed analysis of the tools and medium, as well as step-by-step guides.
ISBN-13: 978-1-55407-635-2 (pbk.)
ISBN-10: 1-55407-635-8 (pbk.)
1. Wood-engraving – Technique. 2. Woodworking tools. I. Title.
761.2 dc22 NE1225.W35 2010

Library and Archives Canada Cataloguing in Publication

Walker, George A. (George Alexander), 1960-
The woodcut artist's handbook : techniques and tools for relief printmaking / George A. Walker.
-- 2nd ed., updated and expanded
Includes bibliographical references and index.
ISBN-13: 978-1-55407-635-2 (pbk.)
ISBN-10: 1-55407-635-8 (pbk.)
 1. Wood-engraving – Technique.
2. Woodworking tools. I. Title.
NE1225.W34 2010 761'.2 C2010-900218-0

Published in the United States by
Firefly Books (U.S.) Inc.
P.O. Box 1338, Ellicott Station
Buffalo, New York 14205

Published in Canada by
Firefly Books Ltd.
66 Leek Crescent
Richmond Hill, Ontario L4B 1H1

Cover design by Sari Naworynski
Text design by Linda Gustafson/Counterpunch

Front cover: Albrecht Dürer, *Rhinocerus*, 1515
Back cover (top): Michael McCurdy, *Turn of the Tide*, 1992
 (middle): Jim Horton, *Humbug*, 2001
Halftitle: George A. Walker. *Dodo* 1988
Frontispiece: George A. Walker. *Whale* 2004
Heraclitus translations by Brooks Haxton, from *Fragments: The Collected Wisdom of Heraclitus*, New York: Viking, 2001.
Wood Fragmented Monoprint and *Wood Print* Copyright © 1966 Ralph Steadman. Reproduced by permission.

Printed in China

The publisher gratefully acknowledges the financial support for our publishing program by the Government of Canada through the Canada Book Fund as administered by the Department of Canadian Heritage.

To my wife Michelle and my sons Dylan and Nicholas!

ACKNOWLEDGMENTS

First I'd like to thank my publishing colleagues: Lionel Koffler, Michael Worek, Brad Wilson, Jennifer Pinfold, Sandra Homer, Ian Murray, Jacqueline Hope Raynor, Mark Huebner, Tom Richardson, Kim Sullivan, Barbara Campbell, Laurie Coulter, Linda Gustafson, Barbara Hehner, Dan Liebman and Sari Naworynski.

Special thanks to all the artists who have submitted work for this project. Their names are listed in the Artist Biographies at the end of this book. Without their help and generosity, this book would not have been possible.

Thanks, too, to the staff, faculty and students at the Ontario College of Art and Design, especially my colleagues in Printmaking. I am also grateful to the members of Open Studio who have shown me community and support for my work; to Nancy Jacobi of the Japanese Paper Place for advice on all things *washi*; to Will Rueter for reading my manuscript and to Jim Westergard, Simon Brett, Michael McCurdy, Barry Moser and Ralph Steadman for making valuable comments and suggestions. Thanks also to Dave Dinsmore for making my wood blocks and for getting bitingdogpress.com off the ground.

Last, but not least, I'd like to extend my thanks to fellow members of the Loving Society of Letterpress Printers and the Binders of Infinite Love, a secret society whose members are always willing to share their knowledge about the book arts.

CONTENTS

FOREWORD

From the strain of binding opposites comes harmony.
– HERACLITUS

A central principle I always teach my students is the value of opposites. Heraclitus said two thousand years ago that art is shaped by the tensions that exist between opposites. "Harmony," he says, "needs low and high, as progeny needs man and woman." This manifests itself in myriad ways: simplicity and complexity, drama and comedy, tradition and innovation, real and perceived, large and small, concave and convex, controlled and accidental, deliberate and spontaneous, to list a few. But of this interplay of opposites, none is more immediate than the contrast of dark line on light surface or light line on dark surface. Without the contrast you see nothing. Simple as that.

This is the fundamental nature of relief prints, which derive most of their graphic and emotive power from the stark contrasts between negative areas of the block that are cut away and appear white, and positive areas that are left standing and print black. It is this directness, this immediacy and simplicity, combined with the fact that they can be printed with the back of a wooden spoon, that lends woodcuts appeal for political statement and social protest.

These are what we might call broad relief prints: capacious in appearance, the result of energetic, spontaneous and often brusque execution. Most beginning practitioners find working with broad shapes in a raw potato, soft wood or linoleum with simple, unassuming tools to be a satisfying, quick and enjoyable enterprise that can be done with relatively little expertise or training. This is not to say that a linoleum cut cannot yield a dense print comparable to a mezzotint, because I have seen just such work done by Eastern Europe printmakers using hypodermic needles to prick minute stipples in

oversized lino blocks producing rich, undulating images of astonishing richness and subtlety. However, this is not the essential nature of the broad printmaking media.

Relief printmaking, a distinctly different approach, produces what we might call fine relief prints. In this category, wood engraving is the benchmark and paradigm.

Wood engravings (and what I call relief engravings that are done in Resingrave, a synthetic substitute for end-grain wood) have a polished and fastidious appearance and are the result of clean, laborious execution that is studied and highly deliberate. There is no such thing as spontaneous engraving. In contrast to the broad prints, I know no engraver who found engraving to be a satisfying endeavor when he or she began. Most, including myself, found it excruciatingly frustrating to produce, with great and undue labor, prints that could just as easily have been done in linoleum. The medium is relentlessly unforgiving. The tools are quirkier, more varied, more expensive and harder to find.

Fine printmaking is tediously slow in both process and production. While engravings can be printed by hand with a wooden spoon or other smooth, hard tool, the most sophisticated engraved impressions, those wherein the ranges of grays are myriad and uniform throughout the edition by intention not accident, are done on the printing press.

Thus wood engraving is absent from sociopolitical commentary. Slow craftsmanship and intellectual consideration do not sting reprobate politicians or corporate thugs as do the big, bold and aggressive prints of a Posada.

Whether it be a broad slap at an arrogant politician, or a meditation on the Divine, the relief print can do it all with natural ease — an ease that results from directness, inartificiality, immediacy and simplicity.

BARRY MOSER, 2005

PREFACE

Y LOVE OF PRINTMAKING — some would call it an obses-
sion — began with the discovery of the powerful graphic
novels of Flemish artist and pacifist Frans Masereel. As
I turned the pages of his books, I began to realize that I too could
use this art form to communicate my own ideas. Because they don't
depend on words, prints can be understood by anyone, anywhere,
and all you need to make one is a graver, a piece of wood, ink, a roller,
paper and a spoon.

Masereel's novels of the 1920s led me to the work done a decade
later by Lynd Ward, who also portrayed the struggle for social justice
and the search for meaning in an often cruel and unforgiving world.
As I learned about the history of printmaking, I was struck by how
often the wood-block print had been used over the years as a tool
of social change and revolution. In my own small way, I joined that
long tradition.

When I was nineteen, I lived in a rundown apartment building in
the heart of Toronto. The roof leaked and every apartment was infest-
ed with cockroaches. One day the landlord disappeared, taking that
month's rent money with him. The bank soon closed in, demanding
that the tenants pay all the stolen rent money. We had no money for
a lawyer, so I pulled out my ink, found a piece of wood and printed
copies of a poster with a vulture on it. When the bank sent inspectors
to examine the building and meet with the tenants, they found the
halls and doors plastered with my prints. The posters brought the
tenants together as a group and gave a voice to our anger and frustration.

In the end, we were able to keep our apartments without paying for our landlord's crime.

I continue to be inspired by the rich blacks, cut marks and impressed lines of wood-block prints. There isn't a single method of learning the secrets of this art. Mastering it requires a journey that each of us begins with our own unique experiences, bringing a personal style that makes our work distinctive.

The Woodcut Artist's Handbook will help you with the technical stuff and provide some tips and tricks to make the journey a pleasant one. The best training in technique is to look at the work of other artists. The generosity of those who have allowed their work to be displayed in these pages is truly appreciated. Unfortunately, some of the richness in the blacks and subtleties of hue that can be controlled in handprinted images are lost in the reproduction process. Nevertheless, the bold gesture of the line and the character and feeling of the original images remain.

As you enjoy the prints in this book and begin making them, I hope you will begin to understand my personal obsession with the wood-block print and, in time, develop an obsession of your own.

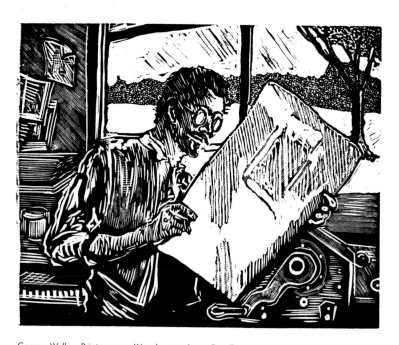

George Walker. *Printer.* 1993. Wood engraving; 4" x 5"

INTRODUCTION

RINTMAKING is all about making an impression on paper, both figuratively and literally. Successful woodcut artists use their drawing, carving and printing skills to create images that have an enduring meaning and make a lasting mark. Making prints is both an art and a craft; it combines the art of creating original images and the craft of making them into prints.

If an image is carved on the flat side of a board, with the grain running the length of the plank, it is called a woodcut. If the image is cut into the end grain of a piece of wood, it is called a wood engraving. This distinction is important. Woodcut and wood engraving are two separate techniques, each with its own materials and tools. Both, however, are relief printing processes.

Although there are four traditional printing methods — relief, lithography, serigraphy and intaglio — this book is concerned only with relief printmaking, and in particular the making of a woodcut or wood engraving. Other materials, such as linoleum and plastics, are discussed as alternatives to wood, but the tools and techniques used on their surfaces are the same as those used on wood. The term "block" refers to the piece of material into which the image is cut. A plank block used for woodcut is called a "wood block"; an end-grain block used for wood engraving is called a "wood engraving block"; and a block made of linoleum is called a "lino block."

To make a relief print, you must cut away the wood in the areas of the block that you do not want to see printed on the page. The raised surface that remains after the cutting process holds the ink and

William Blake *was inspired by* The Pastorals of Virgil *and did 17 engravings for this poem. These wood engravings are often described as some of the most influential ever made because of their impact on artists such as Samuel Palmer and writers such as W. B. Yeats, James Joyce, D. H. Lawrence, Joyce Cary and Northrop Frye. It is said that Dr. Thornton, who commissioned the work, was unhappy with the rough, bold appearance of the blocks. It is this very quality that is appreciated now.*

The Pastorals of Virgil, Eclogue I: Blasted Tree and Blighted Crops. 1821. Wood engraving; 1.38″ x 2.83″

William Morris *and the Kelmscott Press were a major influence on the development of book design and sparked a renewed interest in woodcut in Victorian England. William Morris cut the engraving shown here which was drawn by his close friend Edward Burne-Jones. Morris's wood engraving style owes much to the woodcuts of the Italian and German incunabula of the 15th century.*

Charon's Fee from The Story of Cupid and Psyche. 1865. Wood engraving; 4.22″ x 6.18″

prints, while the lowered surface stays ink-free and does not print. To make a line that will print on paper, two parallel cuts are made in the block. When the wood is removed from these cuts, a raised line remains behind. In a drawing on paper, the black ink lines define the image, but in a woodcut or wood engraving, the excised "white" lines define the image. That is why all relief printmaking is referred to as "the art of the white line."

White line **Black line**

Printing the block can be done by hand or with a printing press. Hand printing is the easiest way to make a print because it requires very little equipment. The block is carved, ink is rolled over the raised surface, the paper is laid down over the block, and the back of the paper is then burnished (rubbed) with a spoon or a special tool called a "baren" to transfer the image from the block to the paper.

In the Japanese woodcut tradition, the novice copied the work of the master until he had achieved a level of mastery in the craft that enabled him to express his own creative ideas. How should you begin? I recommend learning woodcut first and then moving on to the more challenging wood engraving techniques. Start by carving simple shapes and patterns into linoleum or basswood, which are both easy-to-cut surfaces. Learning to cut lines and to make patterns without attempting to create an image will help you gain confidence with the tools. Then gradually challenge yourself with more complex imagery.

Novice engravers should not only start with simple designs but with inexpensive materials. Faced with an expensive boxwood or cherry end-grain block, you may find yourself hesitant to make that first cut. It's a bit like practising basic carpentry skills on pieces of black walnut. A better choice is an inexpensive maple block or one

made of Resingrave, a synthetic substitute for end-grain wood. Learn to engrave straight and curved lines before you take the plunge and start to engrave more complex patterns and shapes.

Keep it simple at first. Relief printing is not a complex, intimidating art. If you've ever made a potato print or used a rubber stamp and stamp pad to make a print, you've had experience making relief prints. In fact, making impressions from raised surfaces is the oldest and most basic form of printing. Although no one knows who made the first relief print, the evolution of this simple technology changed the way we communicate. Being able to create exact copies of images or words made ideas accessible to a large audience.

A Short History

Some scholars trace the woodcut's beginnings to Empress Shotoku of Japan. In the eighth century, she commissioned an edition of two Buddhist good luck poems printed from wood blocks. Others argue that the Egyptians created the earliest block prints to decorate textiles. Regardless of where it was first developed, we know that the technology for printing from wood blocks was eventually introduced to Europe from Japan in the 14th century.

Over the centuries, the European style of wood-block printmaking diverged from the Japanese style. While the Japanese printmakers continued to use water-based inks and pigments applied to the blocks with brushes, the Europeans began experimenting with oil-based inks dabbed onto the block with a stuffed leather ball. Today printmakers everywhere have rediscovered the Japanese style, while some Japanese printmakers are trying out Western techniques, resulting in a crossover of techniques and tools. This book doesn't cover the Japanese technique in detail. If you are interested in learning more, I recommend Rebecca Salter's book, *Japanese Woodblock Printing*, as a good place to start.

The invention of wood engraving is widely credited to Thomas Bewick (1753–1828), a British silversmith and engraver whose illustrations of birds and animals are often cited as masterpieces of the craft. Bewick's apprentices spread the new technology throughout England,

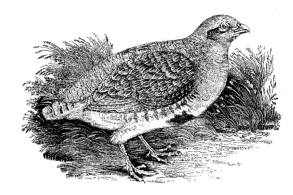

Thomas Bewick. *The Partridge.*
c. 1797. 1.85" x 3.15"

and it was their technical expertise that led the Victorians to expect finely detailed illustrations in their printed ephemera and books.

By the end of the 19th century, the work of the artist, engraver and printer had become separate trades. Most professional engravers in Europe engraved the ink drawings, paintings and wash or pencil sketches created by artists. An unfortunate omission from many histories of wood engraving is any mention of the significant contribution of women engravers to the trade. Women, who in the 19th century were often excluded from professional training, nevertheless engraved many of the dingbats and ornamental decorations that printers offered to their clients. By the 1870s it became commonplace to transfer images as complex as photographs to wood engraving blocks. The Pears Soap engraving on page 18 is just one example of the incredible skill of Victorian wood engravers.

Wood engraving proved to be the most workable method of printing images simultaneously with text set in lead type. But by the end of the Victorian era, wood engraving's use as a commercial printing technique began to wane, due to innovations in plate-making technology. A revival was led by William Morris, who founded the Kelmscott Press in 1891 (see illustration, page 14). Inspired by medieval woodcuts, he wanted to reawaken an appreciation of woodcut and fine typography. Victorian printers had tried to hide the fact that an image had been reproduced on a wood block. It took an artist of Morris's stature to

Albrecht Dürer *is one of the most recognized woodcut artists of all time. His rhinoceros woodcut from 1515, reproduced on the front cover of this book, is one of the most copied images of the 20th century. Dürer's wife sold his prints, which paid better than the small commissions he made from his paintings. The marvelous thing for me about a Dürer print is that the image was cut from a block of wood using only a knife.*

Death and the Lansquenet. 1510.
Woodcut; 3.25" x 4.75"

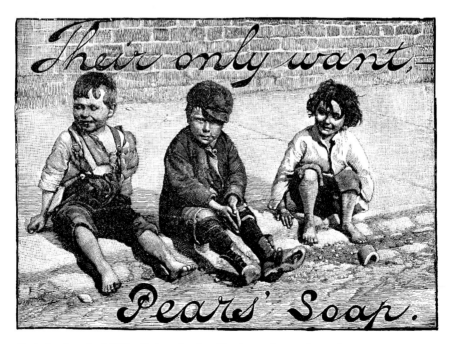

Illustration from *Pear's Shilling Cyclopaedia.* 1899. Wood engraving; 4.12" x 5.75"

recognize the importance of allowing the material to speak for itself, to say, "I'm a wood engraving, not an ink drawing."

A good example of this type of black-line engraving would be the illustrations for *Alice in Wonderland* by John Tenniel (see below). All of his illustrations for Lewis Carroll's famous children's book were wood engravings. In the illustration below, John Tenniel's monogram can be seen in the left corner and the engraver's name can be seen just below Alice's feet in the crosshatching.

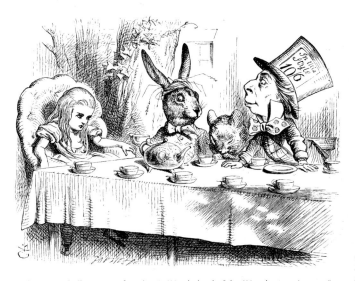

John Tenniel. Illustration for *Alice in Wonderland*. 1869. Wood engraving; 3.5" x 2.9"

Since Morris's time, printing technology has changed dramatically, and woodcut and wood engraving have become the exclusive domain of the artist and craftsperson. Today many types of artists are working in the medium, creating marks and techniques ranging from the inventive and the strange to the staunchly traditional. When you make your first cut into a block, you are joining a long line of artists who have embraced the possibilities of this remarkable art form.

SELECTING MATERIAL
FOR THE BLOCK

HE CHOICE of block material varies from artist to artist and from image to image, depending on the style and technique the artist plans to use. Although I prefer carving into the warm organic surface of wood, other artists cut their images into plastics, soft metals, combinations of materials, and even found objects.

The sketch plays an important part in determining which material you choose. Sketch out your design, then consider the following:

- Will your image be finely detailed? Some materials offer a better surface for detailed work than others. Hardwoods, for example, hold more detail than softwoods.

- Do you want the wood grain to show in your final print? Knots and coarse grains can fight with an image if they appear in the wrong place, or they can enhance an image by providing an interesting background. Edvard Munch, the great Norwegian artist, used the texture and imperfections of the wood grain to great advantage in his work. In the contemporary woodcuts of Helen Frankenthaler, Ralph Steadman and Antonio Frasconi, the grain also forms a vital part of the image and is carefully considered before the work begins.

 If a strong grain appeals to you, the grain in a birch-faced plywood can be roughened with a wire brush to enhance the effect. If you don't want the grain to show, you might choose a maple block with a smoothly sanded surface.

- How large will your final image be? The printing method you will be using and the paper sizes available will help determine the

dimensions of your work. A lightweight material — luan plywood, for example — is a good choice for working large, because it is easy to turn when you're cutting curves into its surface and takes up less space on your storage shelves than heavier materials.

- How much money do you want to spend? Specialty woods such as cherry and basswood can cost 10 times as much as plywood.
- Are you going to buy the blocks ready-made or make them yourself? Local art supply stores sometimes carry small pieces of wood and linoleum for printmaking. You can also make your own wood blocks (see pages 35 and 37) or have a carpenter make them to your specifications.

A favorite wood of woodcut artists is basswood, because it has fewer knots and does not warp as easily as pine. Wood engravers prefer maple and boxwood because of their tight end grains. And cherry, the choice of those who practice the traditional Japanese style of wood-block printmaking, is used on the plank for woodcut and on the end grain for wood engraving. By experimenting with small pieces of wood or alternative materials first and by looking at prints made from different types of blocks, you will find the material that best complements your own style of work.

MATERIALS FOR WOODCUT

Softwoods

Many artists like softwoods — pine, fir, spruce and cedar — for woodcuts. They are less expensive than hardwoods and are believed to be easier to carve, although it's worth pointing out that pine can be harder than basswood.

If you are looking for a wood with knots and a strong grain, pine is ideal. The flat planks found in old pine furniture (the poorly designed pieces even your grandmother would have thrown out) make excellent candidates for blocks, because the wood has been seasoned for a

Paul Gauguin *discovered that the expressive quality of the woodcut was ideal for his planned book on Tahiti, tentatively entitled Noa Noa. The book was never published, but 10 color woodcuts and 30 more woodcuts as monotypes were finished. Gauguin made woodcuts as if they were paintings, scratching and manipulating the surface and then applying the ink like paint, leaving more ink in some areas and rubbing ink off in others.*
Portrait of Teha'amana *for* Noa Noa. *c. 1894.*
Woodcut; 13.75" x 8"

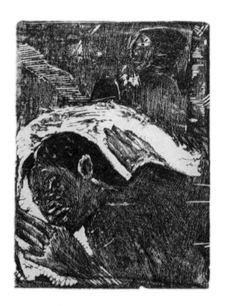

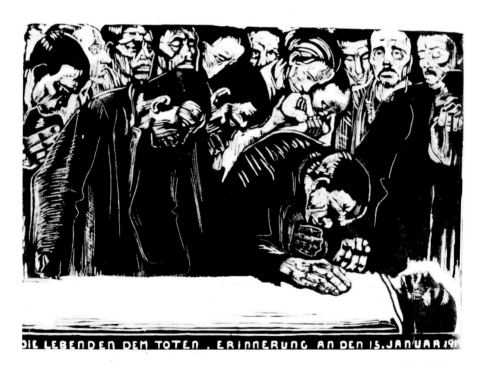

Käthe Kollwitz *is considered one of the great German printmakers of the 20th century. Her woodcuts have a raw power and edge to them that inspires and disturbs at the same time. Her tool marks and the light grays produced by the slightly lower areas in the print add depth and expression to her characters and the atmosphere of the funeral scene in this print.*
Memorial to Karl Liebknecht. *1919. Woodcut; 13.75" x 19.69"*

long time. Spruce planks that have been planed and sanded flat are a good choice for those who prefer an unmarked surface.

Hardwoods

Maple, cherry, poplar, basswood, hornbeam and other hardwoods provide a hard block surface that holds details well. The disadvantage? Tools need to be sharpened frequently and, if your hands aren't strong, the extra pressure needed to cut into the surface can be a challenge. With practice, though, your hands will become stronger. You can also try rubbing a small amount of sesame cooking oil into the surface to make it easier to carve. Once you're used to cutting hardwood blocks, your reward is a strong, durable surface from which to print.

Basswood is a good choice for beginners because it has fewer knots than pine and doesn't warp as easily. Although it is expensive, cherry is especially nice, and the final block can be as beautiful as the prints made from it.

Secondhand oak or maple furniture is a good source for seasoned plank hardwood. Painted, stained or varnished planks can be restored with a belt sander and squared up with a table saw. They can also be left with their original finish intact. Be sure to check the surface, though, for old nails and hardware; they can damage your tools.

Woodcut blocks

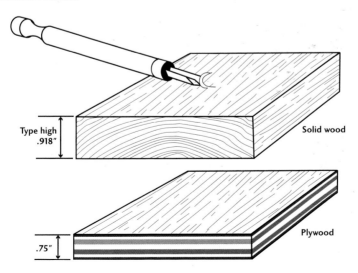

Type high .918" Solid wood

.75" Plywood

Walter Bachinski *creates his work in partnership with Janis Butler, who does the typesetting, presswork and binding for their limited-edition books. He prints his blocks mostly in color with oil-based inks. They print their work on Somerset Satin paper and handmade Japanese papers.*

Ceres illustration for Virgil's *Georgics*. 2004. Woodcut; 6" x 9"

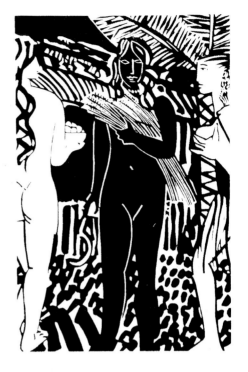

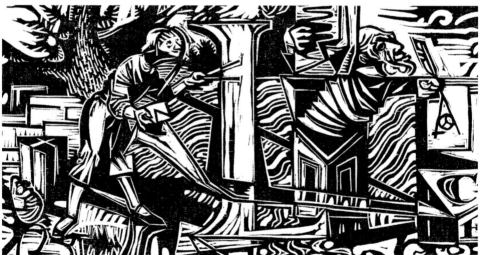

Fred Hagan's *haunting woodcuts illustrated a handprinted book,* Poems for Alice. *I studied printmaking with Fred Hagan in the early 1980s. I remember once when he chastised me for cutting away too much of the block. He told me to let the block speak for itself; after I had imposed my image on its surface I should consider what the block had to say before I continue cutting. Notice how he leaves some of the tool marks in his white areas to print. Hagan was a natural woodworker who loved to see the grain of the wood in the image.*

Illustration for *Poems for Alice*. 1981. Woodcut; 7" x 14"

Plywood

Plywood panels are made by gluing together thin layers of wood, called plies, with the grain direction of each layer at right angles to the previous one. The outer plies are known as the front and back faces and the inner plies are known as the core layers. The greater the number of plies, the flatter, stronger and more expensive the plywood will be.

Good grade plywood provides a flat, smooth surface for carving. Plywood is graded A, B or C according to the quality and appearance of the veneers used for the outer faces. These grades can be applied to one or both sides of the plywood. You can get away with A–B plywood — grade A on one side and B on the other — for woodcuts that will be printed on a press, because only one side of the block is carved and printed. (Carving both sides would make the block unbalanced and difficult to print.) Even if you're interested in a textured grain, it is still best to choose grade A plywood and then roughen the grain with a wire brush.

Plywoods are available in a variety of thicknesses from $^1/_{16}$ to 1 inch. The thinner thicknesses (below $^1/_2$ inch) are usually found only in hobby or art supply stores. The standard sheet size is 4 x 8 feet and is commonly $^1/_2$ or $^3/_4$ inch thick. For printing on a letterpress, the plywood must be $^3/_4$ inch thick and then built up with a few sheets of bookbinders' board or mat board to bring it to type height (0.918 inch, or about $^{15}/_{16}$ inch). For printing by hand or on an etching press, the plywood can be as thin as $^1/_8$ inch. The thinner plywood is easier to handle and organic shapes can be quickly cut into it with a scroll saw or jigsaw.

A large sheet of $^1/_2$-inch plywood purchased from the lumber-yard is the cheapest way to make a big woodcut. I like birch-faced plywood because it has a strong surface veneer that will not dent or mark easily while you are cutting it. Other artists prefer poplar-faced plywood because it has a softer face veneer. Although this makes it easier to carve, it is easily dented if you accidentally drop something on its surface.

Shina plywood is a favorite of artists working in the Japanese printmaking style but can also be used in Western-style woodcut

Osvaldo Ramirez Castillo's *woodcuts are done on large pieces of plywood and basswood and are printed with oil-based inks on washi paper. He favors the parting tool for the sharp, tapered lines that accent the political edginess of his personal narrative. He prints his blocks by hand-burnishing in combination with a printing press.*

¿Who's on my side? Who? 2004.
Woodcut on plywood; 24" x 36"

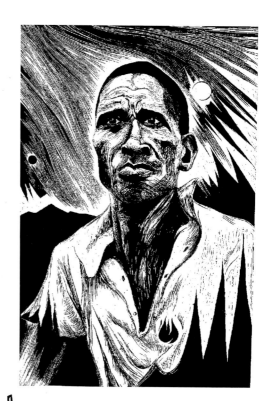

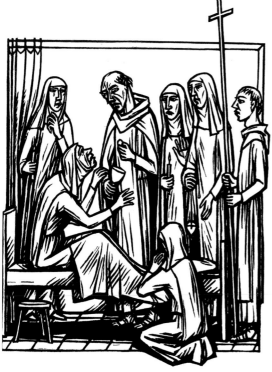

Margaret Lock *carves her mainly figurative woodcuts out of basswood and prints them in black. She says, "The lack of color encourages the viewer to think beyond the representation of the scene to its implications or to its symbolic significance." Her subjects are inspired by medieval and 18th-century literature translated by Fred Lock. She is also inspired by Protestant symbolism and culture.*

The Death of the Abbess from
The Legend of Saint Laura. 2001.
Woodcut; 6.37" x 4.75"

printmaking. Because it is manufactured with a basswood face and a basswood or mahogany core, shina can be cut like a solid plank of wood, is easier to carve across the grain than plywoods with layered plies of different hardnesses and, not surprisingly, is more expensive. It comes in a variety of thicknesses, the most common one being $3/8$ inch, and in sizes ranging from 36 x 48 inches down to as small as 4 x 6 inches. Shina can be carved on both sides if printed by hand and is available from art supply stores, hobby stores and Japanese woodblock suppliers.

Aviation-grade plywood, which is faced in either birch or mahogany, is strong and light with a noticeable grain. Model aircraft supply stores sell it in 3 to 12 ply and in very thin sheets, although more than $1/8$ inch thick is the most useful for printmaking.

American abstract expressionist artist Helen Frankenthaler uses the lightweight luan plywood, made from a Philippine mahogany, for her large woodcuts. Its soft face is easy to cut into and its nearly straight grain provides interesting backgrounds and textures, although it is susceptible to splintering. Luan is available in 3-ply, $1/4$-inch thick planks. It prints lovely unblemished flats of color with a fine, even surface grain showing through.

A light wash of diluted PVA (polyvinyl acetate) glue applied over the surface of a plywood block makes it easier to cut and reduces splintering. (This trick also works on plank-grain wood blocks.) Splintering occurs when the cellulose fibers in the grain lift out during a cut, leaving a chipped edge to the line. This happens most frequently in cheaply made plywood, which is why you should always buy the best plywood you can afford.

Particleboard, Chipboard and MDF

Particleboard, chipboard and MDF (Medium Density Fiberboard) are really not suitable for woodcut printmaking. Particleboard's extremely rough surface, and the type of glue used to manufacture it, make it difficult to cut into. Cutting into MDF board leaves a burred edge of raised fiber particles on the line. And the surfaces of all three will

Paul Hunter *creates his detailed linocuts using only the Speedball lino tool. He likes to cut his blocks on his lap while watching television. While I don't recommend this practice, there is no denying that Paul gets results with his methods.*
D is for Doris *from* The Fatal Circuit.
1991. Linoleum; 2.25" x 3.5"

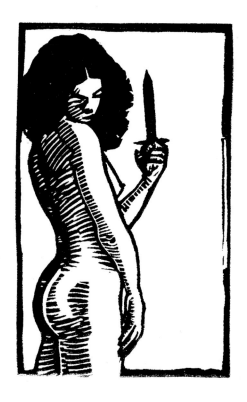

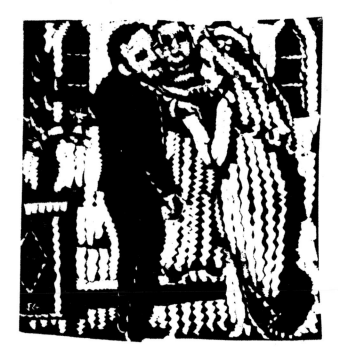

Julius Griffith *carved his linoleum blocks with a gouge that he rocked from side to side as he cut. This gave his images a distinctive ragged edged line. He printed his cuts onto a variety of* washi *papers by hand. I had the privilege of printing many of his linocuts and wood engravings for him.*
The Wedding. *1978. Linoleum; 6.75" x 7"*

dull the keen edge of any tool. However, if you plan to carve shapes with a jigsaw and you like a textured surface, any of these low-grade boards can be used. They can also be cut with rotary power tools, but since these materials tend to chip unexpectedly, be sure to wear safety goggles.

Lino blocks and pieces of plastic are sometimes mounted on these boards to bring them up to type height for printing on a press or simply to make them easier to handle when cutting.

Linoleum

Linoleum is a composite flooring material made by spreading a mixture of powdered cork, rosin and linseed oil onto a backing. Battleship linoleum is the traditional material for linocut. Flooring stores sell it in huge rolled sheets, but smaller mounted or unmounted pieces can be found in art supply stores.

Linoleum provides an ideal surface for the beginner because it is cheap, relatively flat and readily available. Before it can be carved, though, the surface coating must be removed by sanding it lightly with a fine grade sandpaper or steel wool. To make cutting the lino easier, warm it on a warming plate or with a hair dryer. You can also put it in the microwave for 30 seconds — any longer and it will bubble — to soften the surface. To make it easier to print, many printmakers mount the lino onto $3/4$-inch plywood or particleboard using PVA glue.

Linoleum tends to dry out and become brittle with age, making it more difficult to cut. The surface can be somewhat restored by warming it and then rubbing a light linseed oil into it.

In addition to linoleum, printmakers have tried other flooring products with mixed success. Many smooth-surfaced vinyl and composite tiles can be used if they are at least $1/8$ inch thick. You'll have to experiment with these. I've seen both good and bad results.

Rubber and Styrofoam

A popular inexpensive alternative to the harder materials listed above are rubber and Styrofoam. These materials are very popular with

teachers who wish to introduce relief printing to younger students in a classroom setting. Styrofoam and rubber are never printed on a press because they tend to compress easily, thus losing the relief you intend to print from. The Styrofoam used for insulation is the best choice, and is available from most hardware and building supply stores. For rubber you can use erasers, or for larger work a product known as Softoleum (¹/₄" thick). There are many other rubber brands for carving such as Speedball Speedy Cut (³/₈" thick), Steadler Mastercarve (³/₄" thick) and Soft-Kut (³/₄" thick), all available from art supply stores. They sell for between 6 cents and 50 cents a square inch. Rubber and Styrofoam are usually cut with the Speedball cutter, but any of the woodcutting gouges, parting tools or a knife can be used. Because these materials are so soft they are sometimes printed with a stamp pad, the kind used for printing rubber stamps.

MATERIALS FOR WOOD ENGRAVING

End grain

Softwoods are not engraved because the end grain is so porous that they cannot be polished to a fine or hard enough finish. Listed below are the most popular types of wood used by engravers. They can also be used on the plank for woodcuts.

Boxwood

English boxwood, the traditional surface pre-ferred by most engravers, is prized for its clarity (freedom from knots) and its firm grain, which never crumbles under the graver. It can take a century for one of these trees to reach a diameter of 3 inches — half the minimum size needed for making an end-grain block. This helps to explain the high cost of boxwood as well as its scarcity. South African or Cape boxwood and the West Indian or Mara-caibo boxwood are good substitutes for English boxwood.

Canadian artist G. Brender à Brandis reuses his rare boxwood blocks, by resurfacing them so that he can continue to take advantage of the fine surface only boxwood provides. Back in the 1980s, the Sander Wood Engraving Company of Chicago sold old commercial wood engraving blocks to artists, who sanded off the artwork and engraved new images on the refinished surface. I purchased one of these blocks and sanded off an intricate wood engraving of an early computer-typesetting machine. Now I regret sacrificing it for my own work. I own one old block that won't suffer the same fate. It's a partially completed 19th-century boxwood engraving of a skeleton key (see below). It is a masterful piece of work, and a fine example of what can be achieved on boxwood blocks.

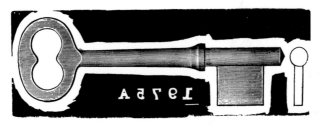

Actual size

Hard Maple

Hard maple, the common term for sugar maple and black maple, is a straight-grained wood with a fine, uniform texture. It is also known by its latin name, *Acer saccharum*. Although its grain is not as dense as that of boxwood, it still cuts reasonably well. In most respects, soft maple is very similar to hard maple, but it does not hold fine details as well. Maple blocks for engraving are available from art supply companies and printmaking suppliers.

Hornbeam

Hornbeam, or ironwood, has a fine, even grain. Its very hard surface is more difficult to engrave than boxwood or maple, but is less susceptible to bruising for the same reason. (With softer woods, the handle or the belly of a tool may press into the surface, leaving a shallow dent, or

"bruise," that can be seen when the block is printed.) Hornbeam holds fine details well and can be worked with power engraving tools.

Hornbeam is not available in ready-made blocks, so if you want to try it, you will have to make the blocks yourself (see page 37). Because hornbeam logs are larger than boxwood logs, it is easier to cut an end-grain block from a single piece of wood.

Fruit Woods

Although traditional Japanese-style printmakers carve cherry on the plank, it can be cut just as successfully on the end grain. This very expensive wood holds fine details without crumbling and withstands long print runs with little wear.

Pear has a very fine, straight and even-textured grain, excellent qualities for wood engraving. Its light-colored surface can be polished to a high luster, is easy to draw on and holds detailed lines well. English sculptor and printmaker Ann Westley recommends pear, saying that with regard to controlling tools as they cut through the block's surface, it is the best wood she has cut on.

Apple presents more of a challenge. Although its very hard surface keeps cut lines sharp edged, the hardness of the wood can vary across the block, sometimes causing tools to slip as they are cutting through the surface. It can also be difficult to see your initial pencil drawing on apple, which ranges in color from yellow to pink to deep orange. Before drawing on the block, some artists paint a wash of white gouache over the surface to make their drawn lines easier to follow. If you are making your own apple blocks and are lucky enough to find a log with a minimum of knots, cut it into small pieces and dry it slowly — large pieces tend to warp severely as they season.

American Holly

Holly has a close grain with a fine texture that cuts easily. The end grain can be polished to a very smooth, fine luster, and pencil or ink lines are easily seen on its ivory surface.

Plastics

Several types of plastic can be used for engraving. They are a reasonable substitute for expensive boxwood and maple, and if you choose a clear, thin plastic, you can place a drawing under it and trace your lines onto the plastic. In other respects, however, plastics don't compare to wood. They tend to pucker, swell and burr when engraving tools cut the surface. Tools also tend to slip on the hard surfaces of most plastics and must be sharpened frequently.

Although I've experimented with copolyester, acrylic and uvex, Resingrave remains my favorite plastic. Richard Woodman developed this white epoxy resin in the 1990s as an affordable substitute for wood blocks. Engraving tools cut into it as easily as they cut into the more expensive boxwood because, unlike other composite plastic epoxies, Resingrave has a compact surface hardness that ensures sharp engraved lines with minimal crumbling. The renowned American engraver Barry Moser swears by these blocks. His exquisite engravings for the Pennyroyal Caxton Press edition of the Bible were all created using Resingrave blocks (see pages 34 and 66).

The older blocks could sometimes crumble under the graver, but this problem has been resolved in Woodman's new formula, Resingrave II. You can cut fine-edged lines into Resingrave II without worrying that your tools will skid or freeze as they often do on other plastics. You can also use a power tool to engrave it without melting.

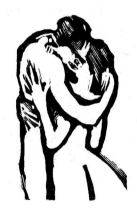

Resingrave is sold mounted on a piece of wood with a combined thickness of about $^7/_8$ inch, and in sizes ranging from 2 x 2 inches to 9 x 12 inches. The block must be raised with card to type height for printing on a letterpress.

George Walker. *Lovers*. 1986.
Wood engraving; 1.25″ x 2″

Barry Moser's *images are engraved on Resingrave blocks. His parallel lines are done individually by hand; no multiple-line tools or power engravers are used. Moser says this about his technique: "My tools of choice are the spitzsticker and the round graver, which I use to re-enter the lines cut by the spitzsticker, widening them to invent a varying tonality. I also use the round gravers to do stippling, and often use it — wagging it back and forth on either side of its vertical axis — to make lines that stutter, and to vary the width of the line in a manner that the spitzsticker cannot."*

Vision of Death. Illustration for the Pennyroyal Caxton Bible. 2000.
Engraving on Resingrave; 7" x 11.75"

MAKING WOODCUT BLOCKS

Before you buy a particular wood to make blocks, it is important to find out how the boards were cut. Both hardwoods and softwoods can be plain sawn (wane sawn) or quarter sawn. Of the two, plain sawing is the most cost-effective way for the sawmill to cut logs into boards. It produces wider boards from the middle of the trunk and requires less set-up work in the mill.

Because plain-sawn boards tend to warp, choose pieces that have been cut close to the log's core. You can determine this by examining the end grain. The growth lines of a board that has been cut close to the core will be nearly vertical rather than horizontal.

Quarter-sawn boards, which have a vertical end grain, are the best choice for woodcut blocks, because they are less likely to warp than plain-sawn ones. They are also more expensive. If you can't tell how a piece of wood has been cut by looking at the grain, you can always tell by the price.

Whether you choose plain-sawn or quarter-sawn boards for your woodcut block, keep the following in mind:

- Choose well-seasoned wood that has stopped cracking and split-ting. The best logs and boards have been seasoned for as long as 10 years. Blocks cut from such wood have a stable surface, ideally suited for cutting fine lines.

Plainsawn

Quartersawn

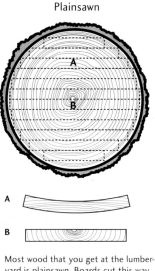
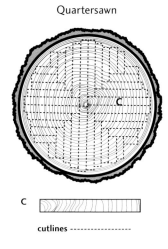

Most wood that you get at the lumberyard is plainsawn. Boards cut this way tend to warp easily (A) except for the pieces closest to the core (B).

Quartersawn wood tends not to warp as easily because the grain on the end is more vertical (C). Quartersawn wood is more expensive and the boards are usually smaller.

- ◆ Boards need to be at least $3/4$ inch thick to prevent them from warping in storage or from cracking during printing. If you are going to print your wood block on a letterpress, mill the board to type height to make it easier to print.
- ◆ Buy your wood at least a week or two before you need it. This gives it time to adjust to your workshop's humidity level. Keep the wood in a dry, flat area and separate pieces with popsicle sticks so that the air can circulate around them.
- ◆ To flatten minor warps in a hardwood board, soak it in water overnight and then place it under pressure while it dries. Severely warped or twisted boards are not recommended for woodcuts because they usually crack under pressure on the printing press.

Blocks can be sanded by hand or with a palm sander to create a smoother surface and to minimize the grain. Sealing the surface of any woodblock with urethane and sanding it afterwards also hides most or all of the grain. Sand up and down with the grain. The smoother the finish on the block, the darker a solid color will print.

MAKING ENGRAVING BLOCKS

Engraving blocks can be made from logs, rough boards, or milled and planed boards. Making them can be a challenge, because the end-grain block must be absolutely flat. However, if you have access to the necessary tools and have the woodworking skills, making your own blocks can be fun and is certainly cheaper than buying them. An alternative, of course, is to provide the following instructions to a good carpenter.

To make engraving blocks from a well-seasoned hardwood log, first cut the log across the grain into pieces 1 inch thick, using a band saw or a miter saw with a sharp, fine-cut blade. Do not cut the log on an angle in an effort to increase the surface area for engraving. This makes the cellulose fibers stand on an angle to the surface and can cause your engraved lines to chip. Logs will crack toward the core, so plan your cuts to avoid these areas.

Many specialty wood suppliers sell rough-cut lumber boards that can be used to make engraving blocks. Sold in thicknesses from 1 to 2 $1/2$ inches and sometimes even thicker, these boards must be milled flat before you can cut out your block pieces. Purchase boards that are 1 inch thick, then mill them to $3/4$ inch. End-grain wood tends to crack easily and becomes especially vulnerable when the wood is under $3/4$ inch thick. Make sure you mill both sides to a smooth, even

Making an Engraving Block

Choice pieces are cut from the log and glued together to make larger blocks.

Jeannie Thib's *linocuts explore the human body and its relationship to natural and cultural history. She likes to work large, preferring the linoleum's skinlike surface and its penchant for printing rich solid blacks. She hand burnishes her large linocuts using a wooden doorknob on washi paper. Thib favors using oil-based inks because of the extended working time they afford. Her favorite cutting tool is the U gouge.*

Glyph. 1994. Linocut printed on Kozo; 6' x 3'

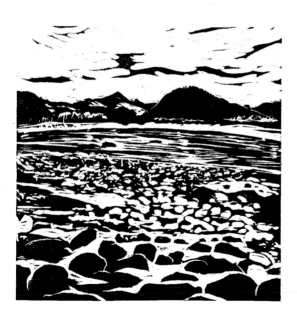

Janice Carbert *works with both linoleum and wood blocks, using a variety of V-shaped and U-shaped gouges to create detailed, high-contrast images. She uses water-based block-printing inks, hand printing with a baren onto Japanese papers. Her current preference is torinoko gampi paper.*

Standing III. 2004. Linocut printed on Torinoko gampi; 7" x 7"

surface, so that the individual blocks will fit tightly together when you butt-join them to make a larger block.

After milling, cut the plank into 1-inch wide pieces. If you just want tiny 3/4-inch blocks, you can finish the end grain with a sander until the blocks are type height. To make bigger blocks, the 1-inch pieces need to be glued together end-grain side up. Alternate the direction of the end grain when doing this (see illustration on page 37) to prevent the wood from cracking and warping and to increase the strength of the finished block. Use a good quality carpenter's (PVA) glue or a wood epoxy that is specially formulated to bond hardwoods. Because poorly bonded butt joints will print as white lines, be sure to clamp the pieces tightly together, following the directions on the glue or epoxy container for clamping and drying times.

The next step is to sand the block to type height. End-grain blocks that are thicker than type height can be used for hand printing, although I would never use one over an inch thick because I find such blocks too heavy and cumbersome. The pros use a thickness sander, but it's simple to make a low-cost substitute. Using spray adhesive, simply attach sandpaper to plate glass, a piece of marble or any other flat, smooth surface.

Some block makers begin the sanding process by scraping the block's surface with a special wood scraper to remove any obvious irregularities. Others start with a coarse sandpaper and work their way to super fine paper for the finishing polish. With the coarser sandpaper grades, I use a back and forth motion, and with the finer grades, a circular motion seems to work well. It takes a bit of practice to make your blocks perfectly flat, but it will save you time when you print if you can get them as level as possible. You should not see any scratches or feel any variations in the surface when you're finished.

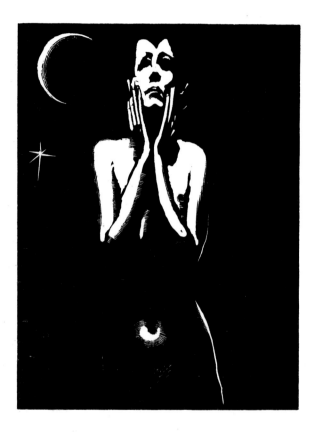

George Walker. *This is one of 10 wood engravings to illustrate Neil Gaiman's* Snow Glass Apples. *They were handprinted on washi paper and sewn into a limited-edition book. This image took very little time to engrave because the block is mostly black. The majority of the work was in the preparation of a block that was absolutely flat so the edges and middle would print solid. The test block on the opposite page is a good example of how a block will print before and after it is prepared for engraving.*

The Queen. Illustration for Neil Gaiman's
Snow Glass Apples. 2002. Wood engraving; 3″ x 4″

TESTING THE BLOCK

After sanding the woodcut or wood engraving block, I usually trim about ⅛ inch off the edges, because they are often lower than the rest of the surface area. Some artists bevel the edges of their blocks with a file to eliminate this problem.

Printing an uncut block as a solid black is the best way to find out if it needs to be trimmed or sanded again. If the block is not flat, the edges will print lighter than the middle. Cracks and scratches remaining on poorly finished blocks will also appear on the proof from the printed block (see illustration below).

If you've printed a test and find imperfections, clean the ink off the surface of the block with a dry cloth and then continue sanding it to remove the problem areas. Or you can cut out the problem area altogether and print it as white space. If you are hand printing your block, many of the surface variations in an uneven block can be burnished more vigorously and, if necessary, re-inked until a satisfactory impression is achieved. You can also fill cracks with wood filler, epoxy or auto body scratch filler; however, avoid this whenever possible on plank wood and avoid it completely on end-grain wood. Wood fillers tend to change the surface, making it more difficult to cut. Furthermore, any obvious change in the surface will show when the block is printed, defeating the whole purpose of the exercise.

Leveling the Block

Test the block by printing it to see if it is smooth and level.

A GOOD SET OF TOOLS

T's IMPORTANT to work with a good set of basic tools. Tools made from high-quality steel are initially expensive but will last a lifetime. Cheap tools never sharpen properly and will let you down again and again. They are never a bargain.

Keep your tools sharp and store them in a dry place, preferably a cloth tool holder or an old velvet-lined cutlery chest. Whatever you do, don't throw them into a box where they'll knock together, dulling the blades that you took so much care in honing to perfection.

Wood cutting tools

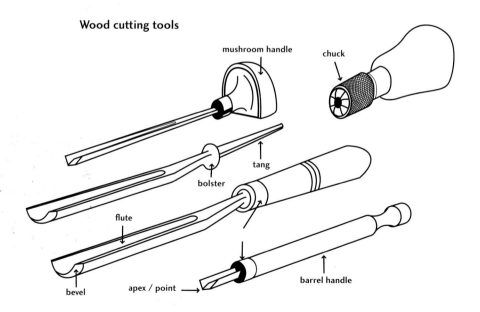

TOOLS FOR WOOD
AND LINO BLOCK CUTTING

A small gouge, a knife and a bench hook are all you need to begin cutting images into wood or linoleum. You can augment these basic tools with extra gouges, parting tools and power tools.

Gouges

These tools produce a rounded line. Most woodcut artists use a straight gouge for cutting; however, some like to use a bent gouge when they have large amounts of material to remove from the block. Its bent shank makes it easier to exert the pressure needed to do this. Spoon gouges — straight gouges with a spoon-shaped cutting edge — produce a more concave white line than regular gouges.

Gouges are available in a wide selection of sizes, from small detailing tools to large monsters used for creating white space on enormous woodcut blocks. The sizes, ranging from $1/8$ inch to 1 inch, indicate the maximum width of the line cut by each gouge. My favorite widths are $1/4$ inch and $3/8$ inch.

Gouge

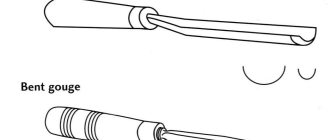

Bent gouge

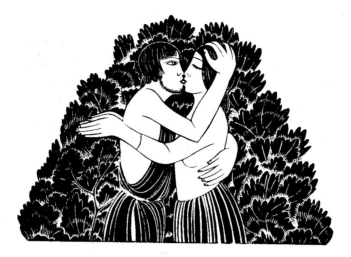

Eric Gill, *sculptor and master wood engraver, produced hundreds of wood engravings including illustrations for over 100 books. An eccentric spiritual artist, Gill's ideas of religion and lust provided significant inspiration for many of his designs.*
The Kiss. 1925. Wood engraving; 2.5″ x 3.5″

Franklin Carmichael *was an accomplished wood engraver, as seen in the print above. One of my favorite quotations by Carmichael is, "It is imperative that the artist reveal through the medium in which he is happiest."*
Illustration for *The Higher Hill* by Grace Campbell. 1944. Wood engraving; 3.25″ x 3.87″

Knives

The knife was the first woodcut tool, and even today it is the only tool used by some artists to create their work. A first cut is made with the tip of the blade to outline the image and then a second cut is made on an angle to the first, which disengages a sliver of wood alongside the line. Choose a blade with a 30-degree to 45-degree angle, tapering to a point at the tip of the blade that allows you the maneuverability necessary to carve curved lines.

Knives suitable for wood and lino block cutting are available in a variety of shapes and forms, from Japanese knives to X-acto blades. I like the Japanese woodcut knife called the *hangit,* which is sold in both right- and left-handed versions. Its penlike shape makes it easier to handle than a mat knife. But it doesn't really matter what type of knife you choose as long as it feels comfortable in your hand while you work.

Japanese knife

Mat knife

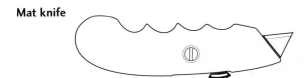

X-acto knife

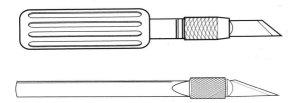

Parting Tools

Also called V-shaped cutters, parting tools produce a tapered line. Although a 45-degree tool is sold, the 60-degree straight or bent parting tool is the most popular. (The angle indicates how far the tool's wings are set apart.) I prefer the straight version myself, because I use this tool for creating tapered lines rather than for clearing material. Parting tools can be purchased in sizes from 1/8 inch to 3/8 inch and larger, depending on the width of tapered white line you want to make.

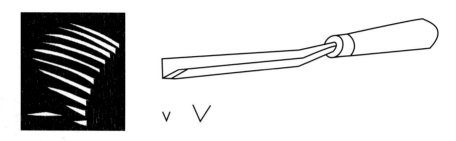

Veining Tool

This tool is a very small version of the parting tool. It is used for tiny details that would be difficult to make with the larger parting tool.

Speedball Linoleum Cutter

This is an inexpensive tool with interchangeable disposable blades for cutting linoleum. Its one disadvantage is that the blades cannot be resharpened easily; however, the tool and its replacement blades are inexpensive, making it a good alternative to the more expensive tools. Sets contain the basic gouge, knife and parting tools.

The Speedball cutter is the only tool Canadian artist Paul Hunter uses to create his very detailed linocuts. I don't recommend

carving hardwood blocks with it, but it's fine for cutting lino and softer woods.

Speedball also manufactures the Linozip. Its V-shaped tool bits are called "liners" because they are used for cutting white lines in linoleum. Unlike other tools, the Linozip is pulled toward you rather than pushed away from you through the block. It is held in the fist of one hand while the other hand steadies the block from behind the tool's path. Although Linozips were developed for use with linoleum, many of my students have used them successfully on wood blocks.

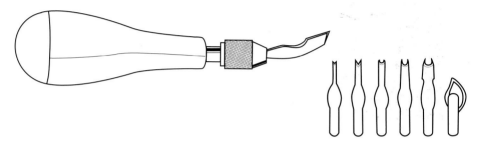

Chisels

A chisel is a bar of steel with a beveled edge. It is used in woodcutting to remove material from large open areas that you do not want to print. The size you select will depend on the space you will be clearing. I use a 1-inch chisel for clearing large areas and a ¼-inch chisel for clearing small areas. Small-ended chisels are also handy for clearing any slivers that may be sticking up at the bottom of wide lines, and for straightening corners.

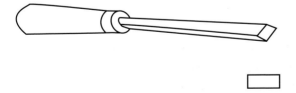

Wire brush

If you love the grain on a piece of wood, a wire brush is a great tool to enhance it for printing. Brush in the direction of the grain to remove the softer fibers, leaving the harder fibers raised and ready to print.

Wooden Mallet

A mallet can be very useful when you are cutting a large block. Dense woods sometimes require a little more pressure than your hands can muster to guide your gouge or chisel through them. The mallet is used to lightly tap the tool through the surface.

Bench Hook and Clamps

To protect your hands and steady the block while you cut, a bench hook, C-clamps or hand clamps should be used. If you use clamps, insert a piece of soft card between the block and each clamp to protect the block's surface.

A bench hook is easy to make and may save your hands from a serious cut. It is simply a piece of plywood with two small boards nailed on opposite ends, top and bottom (A). This creates a hook on one end that can be placed on the edge of a workbench or table and a stop on the other end to push against while cutting. Pegs inserted into the head of the bench hook will provide more places to brace the corner of the block when cutting (B). A V-shaped groove cut into the stop board (C) makes it easier to cut angled lines and curves on larger blocks.

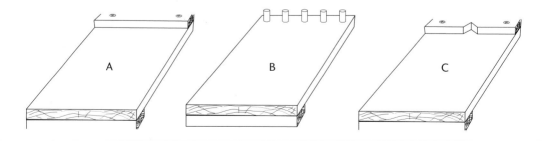

TOOLS FOR WOOD ENGRAVING

To cut on the end grain, you need only one basic tool: a graver. You can add a spitsticker, scorper and lining tool later when you feel more ambitious. However, buying engraving tools in sets is less expensive than buying them individually. Basic sets are available from print-making supply stores and tool manufacturers. You'll also need a sand-bag or similar object to support the block.

Parts of the engraving tool

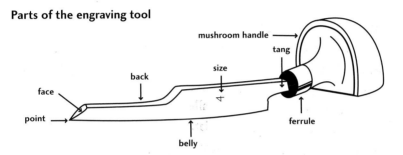

Gravers

The graver (called a "burin" by metal engravers) has two basic forms: one has square blades and one has diamond-shaped blades. The angle of the cutting edge or face is honed to between 30 degrees and 45 degrees. The tang of the graver, just before it enters the handle, is bent to prevent the tool from bruising the wood.

These tools create tapered lines. The deeper the graver is driven into the wood, the wider the line becomes. The diamond-shaped graver creates lines that are fine, deep and of variable widths. The square graver reaches its maximum width more quickly.

Spitstickers

"Spitsticker" derives from the Old English words *spit,* meaning "sword," and *stick,* meaning "to pierce." Also known as an elliptic tint tool, it is designed for making curved lines of an even width. Many engravers use it as their primary line-maker.

The sides of the spitsticker are convex and, unlike the graver, will not bruise the wood when cutting curves. The face is usually ground to a cutting angle of between 30 degrees and 45 degrees. A bullsticker is a thicker version of this tool and creates lines that widen quickly from their starting point. I find the Lyons #4 (medium fine) and #8 (heavy) spitstickers the most useful.

Tint Tools

Designed for engraving parallel lines of uniform width to create gray tones or tints, these tools are available in a variety of sizes from fine to wide. I make most of my parallel lines with a Lyons #6 (medium) tint tool. Unlike the graver, variations in pressure and depth do not affect the width of the line produced by this tool. It should enter the wood at a fairly steep angle before leveling off to the cutting angle. This prevents the belly of the tool from causing any damage to the surface just behind your incision.

Scorpers

Scorpers, also called round gravers or scamples, are used for clearing areas, cutting broad white lines and creating coarse stippling effects.

Flat Gravers

These tools, which look like small chisels, are effective for removing sections of the block you do not want to print. A Lyons #40 (narrow) for clearing wide lines and a #46 (wide) for clearing large areas are the most popular. A conventional chisel or power tool will also accomplish these tasks.

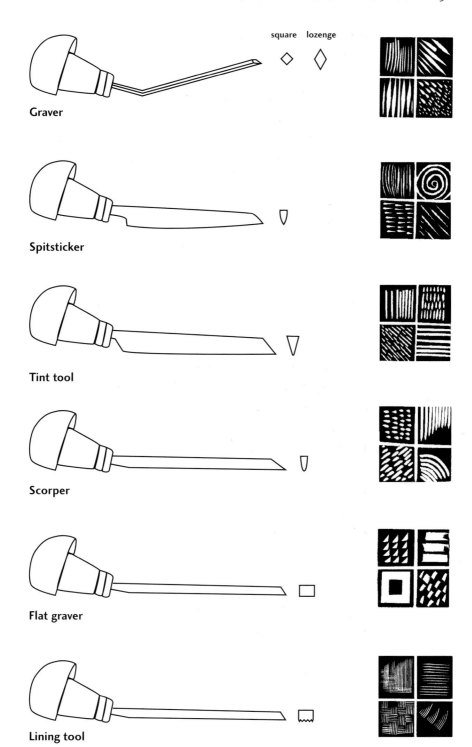

square lozenge

Graver

Spitsticker

Tint tool

Scorper

Flat graver

Lining tool

Multiple Liners

The tiny teeth of this tool engrave multiple parallel lines with one stroke, which is useful for creating tonal effects. However, you should avoid a lining tool with too many teeth that are too close together (32 teeth in ⅛ inch, for example): the lines it produces will be too weak to withstand the pressure of printing. The finest one I have, a Lyons #55, is ⅛ inch wide and engraves five lines at once.

Awl

This is simply a pointed piece of steel used to create stipple effects and white dots of various sizes. You can make an awl by drilling a hole in a piece of dowelling, gluing a nail in the hole, and then sharpening the nail's end to a point on a grinder.

Roulette Wheel

Also called a tracing wheel, this tool has a small wheel that looks like the spur on the heel of a cowboy boot. Rolling the wheel over a block's surface produces a series of dots running in a line. It's an excellent tool for creating a dotted stipple effect quickly.

Power Engraving Tools

Power engraving tools are suitable not only for cutting end-grain and plank wood blocks but also for carving plastics. Some models are sold with a flexible shaft attachment similar to a dentist's drill.

The attachment makes it easier to maneuver the cutting bit. I use a Dremel but the Foredom, Roybi, and Black and Decker rotary engraving tools perform equally well.

Router

This is another good tool for removing large open areas that you do not want to print. However, the difficulty in using a heavy-duty, full-sized router to cut out areas on a small block becomes apparent when you try to do it. Controlling the cutting by restricting the movement of the block or the router is the key to success with this tool. I have a router mounted to a frame that allows me to move the block under the router blade bit. You can use a drill press to do the same thing.

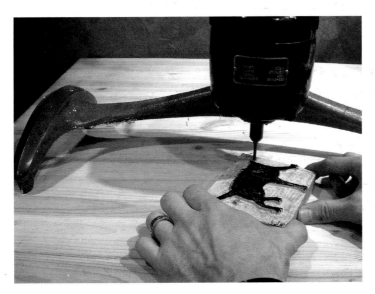

Clearing areas of the block with a router.

Laser

Although the laser is far too expensive for personal use today, it may become a popular wood engraving tool in the future as prices come down. It can generate crisp, highly detailed designs and lettering on the surface of a variety of organic and synthetic materials. The laser engraves wood more deeply than most tools, giving the work a rich look of precision and depth. On a light wood, the image looks as though it has been burnt into the surface, while on a dark wood the design appears to have been painstakingly carved.

The laser's primary disadvantage is the angle of the cut it makes. It cuts straight downward, resulting in a 90-degree angle instead of a more desirable 65-degree angle. On a traditional engraving, the slight bevel on each line gives it strength when pressure is applied to it during the printing process.

Engraver's Sandbag or Pad

This is a leather cushion tightly packed with fine sand to give it weight and stability. It provides a surface on which to rest the block, makes it easier to turn the block when carving curved lines and keeps your non-cutting hand safely below the cutting surface.

SHARPENING YOUR TOOLS

All tools in routine use need sharpening at regular intervals, for two reasons. First, you cannot do woodcut or wood engraving properly with dull tools. The cuts they make have torn edges that do not print well. Second, dull tools are dangerous. They require more pressure to cut into the block and are more difficult to control. If you accidentally cut yourself with a dull blade, the wound will be more severe and take longer to heal. The simple precaution of sharpening your tools makes the woodcutting or engraving experience much safer and a lot more fun.

Stones, Strops and Wheels

Tools are sharpened with synthetic or quarried abrasive stones. Most sharpening can be done with two grits — coarse (100x–600x grit) and fine (1200x–8000x grit). The coarse stone shapes the metal and removes nicks; the fine stone keeps the edge sharp and smooth. Most stones are long rectangular blocks, but they are also available as combination stones, with coarse grit on one side and fine on the other, and as cones or wedges for honing gouges and removing burrs from the sides of tools. A leather strop can add the final touches if your finest grit stone will not do the job (see illustration on page 59).

Water Stones

Water stones, which use water as the lubricant, are now manufactured, but at one time they were made from quarried natural stone. I prefer Japanese water stones to traditional oil stones. Made of aluminum oxide bonded with resin, they are cleaner to work with and sharpen tools more quickly. Their one disadvantage is their tendency to groove and wear down with use in a short period of time. Because a tool can't be honed accurately with a grooved stone, the stone's surface must be reflattened frequently.

The easiest way to flatten a water stone is to rub it on a piece of

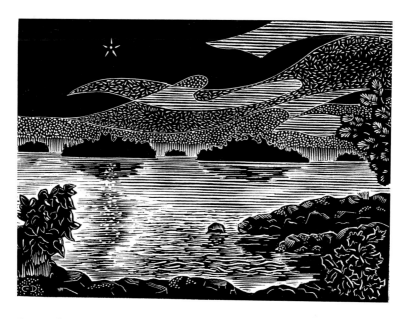

Guy Debenham *was a surgeon who took up the graver to express his love of the Canadian landscape. He loved to play with pattern and texture. The sky pictured here is a good example of what can be achieved with some stippling using the graver and an awl. See how the patterns overlap and give the impression of movement.*
Christmas, Georgian Bay. 1990. Wood engraving; 3" x 4"

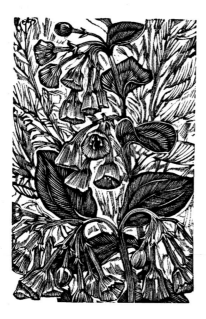

Gerard Brender à Brandis *prints his engravings on handmade paper when possible. He engraves on boxwood or kamassi (Cape boxwood from South Africa) end-grain blocks, and prints with oil-based inks.*
Bluebells. 2005. Wood engraving; 2" x 3"

120-grit silicon-carbide wet/dry sandpaper that has been taped or temporarily glued to a flat base, such as plate glass or a press bed. Another way is to grind the stone on a true litho stone or a piece of limestone or marble sprinkled with fine 120 Carborundum powder. Move the stone in a figure-eight pattern on the sandpaper or powder, with water, until the surface is true.

Water stones are available in coarse (800x), medium (1000x), medium fine (1200x) and polishing (6000x) grits. A combination stone of 1000x/6000x, or separate stones of 800x and 1200x, are good choices for someone starting out.

Oil Stones

Natural Arkansas stones are the best oil stones. They are available in soft (medium grade) and hard (fine grade) stones. The hard stones will give your tools a keener edge and a more polished finish than the soft stones, but they clog faster. Use a soft stone for sharpening tools that have nicks and uneven surfaces, then finish the job with a hard stone.

Aluminum oxide oil stones are good man-made stones. They are sold in a 90x/600x combination.

Never use an oil stone without lubricating oil. A light mineral oil is best and keeps metal particles from clogging the stone. The stones can be cleaned with a soft cloth and the oil. If the stones are extremely clogged, use fine Carborundom powder with lots of oil and rub the surface until the abrasive frees the metal particles from the stone. Although soft oil stones take longer to groove than water stones, they do need a bit of truing after a while. (Hard oil stones rarely need to be trued.) To do this, rub a hard stone and a soft stone together, with a layer of oil between them. They can also be trued with fine 120 Carborundom powder and oil, using the same method.

Ceramic Stones

Ceramic sharpening stones do not become grooved with use. One manufacturer claims they are non-lubricating, meaning there is no

Michael McCurdy *has the privilege of being heir to the tools of the great Lynd Ward.
Those tools have magic in them, so I'm not surprised that Michael has made them work
magic again in his capable hands. He likes to print on Rising Photolene paper with a
1932 Vandercook 219 proof press. He uses a Dremel tool to remove large open areas and
various gravers for his line work, usually on end-grain maple. Michael has this tip
for transferring his images: "I do a cartoon on tracing paper and transfer that image
to the block using carbon paper. I then roll printer's ink over the block to darken it."*
Turn of the Tide. 1992. Wood engraving; 3.35" x 5"

Wesley Bates *prints his fine
wood engravings on his Chandler
and Price platen press. Bates uses
only hand tools when making his
engravings, clearing white spaces
with his flat chisel and round graver.
For most of his details Wesley's tool
of choice is the spitsticker. He prefers
to print on Mohawk Superfine paper.*
Circle Angel. 1986. Wood engraving;
2.94" x 2.94"

need for oil or water. However, I've found that a bit of water and dish detergent wiped now and then over the surface cleans the pores and prevents clogging. Suppliers sell an 800x grit dark stone for shaping at the initial sharpening stage and an 8000x grit white stone for the final honing and polishing process. Ceramic stones are a good investment for the serious artist.

Monocrystalline Diamond Bench Stones

These expensive diamond stones sharpen tools quickly and are harder than silicon carbide or aluminum oxide stones. Oil or water lubricant is not required. They are good for basic sharpening and honing, or for truing water or oil stones, and are available in fine (600x and 1200x) and coarse (220x and 325x) grades. They can be cleaned with a bit of water on a damp cloth.

Leather Strops

Stropping, the final step in the sharpening process, will make your tools shine and give them a razor-sharp polished edge. A leather strop rubbed with honing (buffing) compound, or oiled and rubbed with very fine 320 Carborundum powder, is used for this task. Look for good-quality untanned belt leather to make a strop. Leather contains silica and is mildly abrasive even without a honing compound.

Honing

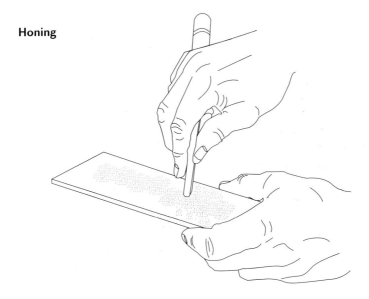

Grinding Wheels

I try to avoid using a power grinding wheel because it is very easy to damage tools by grinding away their edges or, worse yet, by changing the temper of the steel. Tool steel is tempered by heating it to a very high temperature and then cooling it at precisely the right moment to harden the metal. The heat of a grinding wheel can reverse this process. You know you've killed a tool on the grinding wheel when its color changes to a steel blue. Nothing will help at this point; the tool won't hold its edge anymore.

Sharpening Woodcut Tools

In general, the cutting edge of a woodcut tool is sharpened by holding its face flat on the stone and moving it with an even, constant pressure back and forth, using plenty of lubricant. Keep the tool's face at the same angle throughout the process.

Unlike kitchen knives, knives for woodcut have only one beveled edge; the other side is flat. The beveled edge of the blade is sharpened by moving it back and forth on the stone while maintaining the angle of the cutting edge. Sometimes the flat side also needs to be trued. This is done by rubbing it across the stone several times.

To sharpen the beveled edge of a chisel, move it in a side-to-side motion over the length of the sharpening stone. The 60-degree angle of the bevel should be maintained throughout the sharpening. The flat back of the chisel can be trued to remove the burr by keeping the belly of the tool flat on the stone and moving it from side to side.

The parting tool looks like two chisels joined together. It is sometimes difficult to keep the bevels of the two wings and the place where they join evenly sharpened. If you manage to keep the bevels of the wings even, you may still find that the keel is blunt and the point hooked (see illustrations, bottom of page 61). Trying to maintain a square sweep on the wings can also be challenging (see Wing sweep illustration, top of page 61). A sweep that is too far back will weaken the point, and if it becomes too weak, it may chip off. A sweep that is too far forward will make it difficult to maneuver the tool on the block and can make the top edges of the wings vulnerable to chipping.

Wing sweep

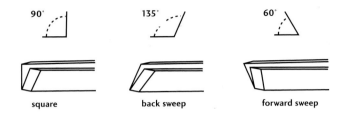

square back sweep forward sweep

Parting tool Short bevel

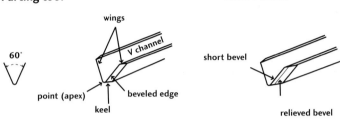

To avoid these problems, alternate the sharpening of the bevels, rubbing them on the stone in a to-and-fro motion. Some carvers prefer to have a short bevel as well as the main bevel on the wings (see Short bevel illustration above). A short bevel is faster to sharpen and provides more maneuverability when cutting curves. Don't ignore the keel or the sharp wings will be worthless. And don't forget to hone the burr off the inside of the wings with a triangular slipstone or small leather strop. At the end of the process, which admittedly takes a little practice, your parting tool should have a square wing sweep, even bevels and a keel that rises to a sharp apex where the wings meet.

Sharpening problems

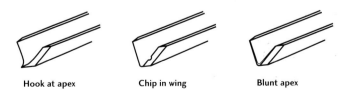

Hook at apex Chip in wing Blunt apex

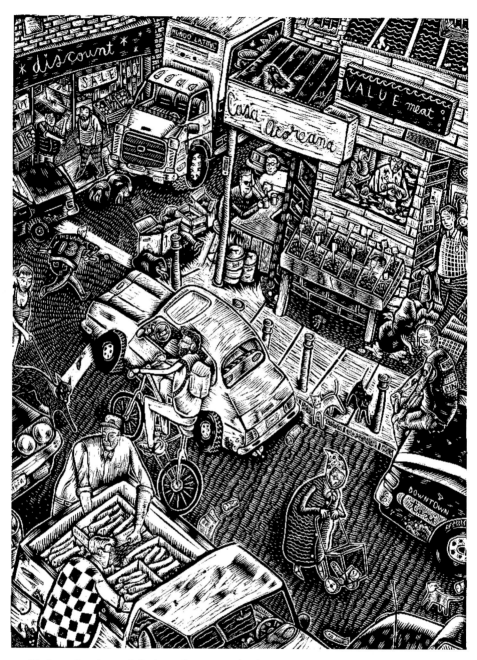

Christopher Hutsul *depicts urban settings on his large linoleum cuts. He has approached the printing of these images in several ways: by hand burnishing using oil-based inks; by running them through an etching press onto sheets of Arches paper; and by transfering images to a screen to be printed as serigraphs. His images are always playful and detailed.*

Kensington Market. 1999. Linocut; 17" x 23"

The gouge can be sharpened on a flat stone or a cone-shaped stone. When using a flat stone, move the blade edge to and fro along the length of the stone while rocking the tool from wing top to wing top. With a cone-shaped stone, move the gouge back and forth along the length of the stone, again rocking the tool from wing top to wing top. When the edge is sharpened, hone the inside of the gouge with a round wet stone or small leather strop folded to make it round at the end (see illustration below). Another neat trick is to make a cup-shaped groove in a flat stone with a blunt steel bar (the same size as your gouge) and lots of lubricant. Of course, this means you can't use this stone to sharpen anything but gouges.

Test the sharpness of your woodcut tools on a scrap of wood. Sharp tools cut easily, leaving lines with clean, sharp edges that print crisply.

Sharpening the gouge

Sharpening on a flat bench stone

Sharpening on a cone-shaped stone

Honing with leather strop

George Walker. *Desire.* 2002.
Woodcut on basswood; 4.5" x 6"

Sharpening Engraving Tools

Sharpen an engraving tool by holding its face flat on the stone and moving it with an even, constant pressure, using plenty of water or light oil, depending on the type of stone. The correct angle, which is with the face of the tool flat on the stone, must be maintained and the pressure should be firm but not excessive.

Face angle

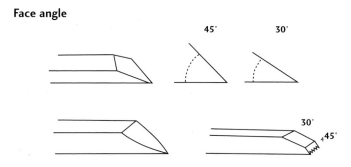

Common sharpening problems with engraving tools

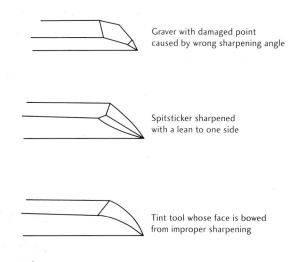

Graver with damaged point caused by wrong sharpening angle

Spitsticker sharpened with a lean to one side

Tint tool whose face is bowed from improper sharpening

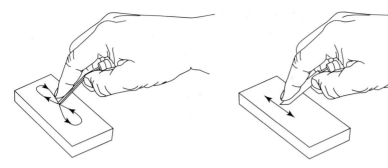

Figure eight **Back and forth**

The face of most engraving tools are beveled between a 30-degree and a 45-degree angle. An angle of 30 degrees is best because it allows the material being cut from the block to move over the tool rather than to curl in front of it. Gravers, spitstickers and tint tools are sharpened using a circular or figure-eight motion. This helps prevent grooves from forming on the stone. Chisels, scorpers and lining tools are sharpened using a back-and-forth motion. Sharpening jigs are handy for holding engraving tools at a constant angle while sharpening. The Crocker sharpening jig is the most popular for sharpening engraving tools. They are used with a back-and-forth motion as well. Sometimes it is necessary to rub the sides of the tool on the stone to remove any burrs that have formed on the edges of the face.

After sharpening my tools, I like to test them on a scrap of end-grain wood. The tool should cut effortlessly. A careful examination of the cut mark should show a clean incision with no signs of tearing. If the tool requires a lot of pressure to move it through the wood, it is likely not sharp enough. Sharpen your tools every hour or so when you are engraving.

George Walker. *Driver.* 1998. Wood engraving; 5.125″ x 1.75″

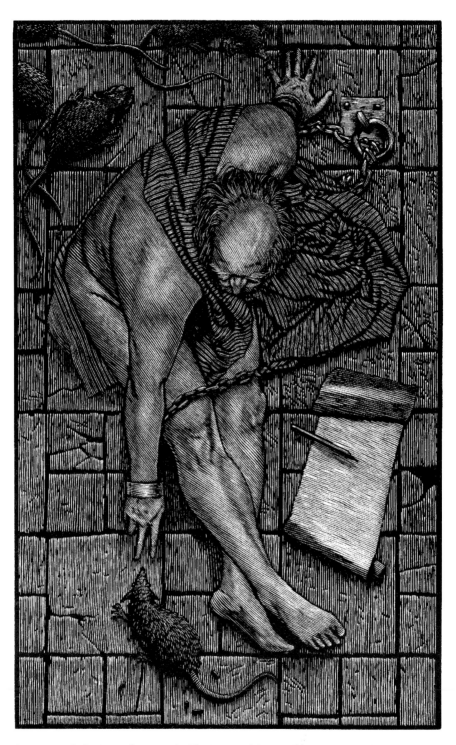

Barry Moser. *Paul in Prison.* Illustration for The Pennyroyal Caxton Bible. 2000.
Engraving on Resingrave; 7″ x 11.5″

CREATING WOODCUTS
AND ENGRAVINGS

TRADITIONAL Japanese woodcut printers sat on the floor at a low, angled table to create their work. Everything was done in a very small but efficient space. You may not want to sit on the floor, but a comfortable space can make the difference between a rewarding creative experience and a discouraging, frustrating one.

PLANNING A WORKSPACE

Furniture, lighting, health and safety issues, and storage are the four factors to keep in mind when planning a studio space.

Ideally you need at least two tables — one for cutting your blocks and one for printing. A third table for sorting paper is helpful if you have the space. The size of the table tops depends on how big you like to work. For most people a 30 x 60-inch table is fine. Some printmakers prefer to stand at a workbench when cutting their blocks. If this appeals to you, the bench should be just below chest height to protect your back while working. My own tables are 30 inches high and have sturdy legs. Nothing is more frustrating than cutting blocks on a table that wobbles.

George Walker. *Skull*. Illustration for Bram Stoker's *In the Valley of the Shadow*. 1997. Wood engraving; 0.875" x 4.25"

Studio layout

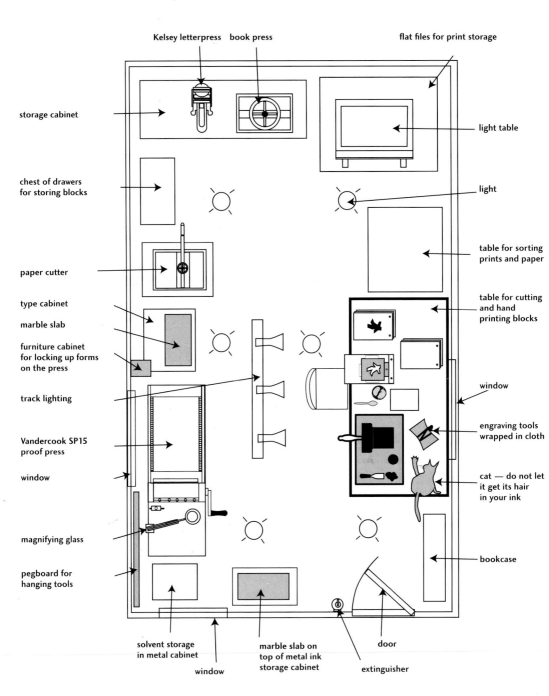

Kelsey letterpress book press

flat files for print storage

storage cabinet

light table

chest of drawers
for storing blocks

light

paper cutter

table for sorting
prints and paper

type cabinet

marble slab

table for cutting
and hand
printing blocks

furniture cabinet
for locking up forms
on the press

window

track lighting

engraving tools
wrapped in cloth

Vandercook SP15
proof press

cat — do not let
it get its hair
in your ink

window

magnifying glass

bookcase

pegboard for
hanging tools

solvent storage
in metal cabinet

marble slab on
top of metal ink
storage cabinet

door

window

extinguisher

If you are going to sit to do your work, use a comfortable chair with good back support. Drawing, sharpening tools and cutting blocks takes time and you'll appreciate the extra support a good chair provides. To prevent injuries that can result from doing repetitive tasks in the same body position, Canadian wood engraver Jim Westergard alternates between a kneeling chair used with a specially built plywood stand and a conventional chair and table.

Make sure you have enough light flooding your studio. Although natural light is best, I use four warm 50-watt spotlights above my worktable when I'm cutting blocks at night or on dull days. Color-corrected light bulbs, which show more of the color spectrum than ordinary bulbs, are great for mixing colors or doing any color work. Whatever artificial lighting you use, be sure to position it so that it doesn't cast shadows over your work area.

Every studio needs good ventilation, particularly when oil-based inks and solvents are being used. A window or a built-in fan is mandatory. It is also a good idea to take a look at the Material Safety Data Sheets (MSDS) for the products you plan to use in your printmaking. Manufacturers or suppliers of potentially hazardous materials must have these product information forms available for their customers to look at. The forms state the risks involved in using the product and what to do in case of accidental poisoning. They are available from your supplier or on the manufacturer's web site.

When using oil-based inks, I clean up my rollers, ink slab and ink knives with vegetable oil or a vegetable/coconut oil-based solvent known as estisol because it is not as smelly or toxic as mineral spirits and other solvents. An ammonia-based cleaner removes the oil film left by the vegetable oil. I still use mineral spirits once in a while to clean rollers and slabs that have a buildup of vegetable oil film on them.

You can clean ink-splattered hands with a rag and an industrial hand cleaner containing pumice. The constant use of hand cleaners can remove the natural oils in your hands, so use a hand lotion after you've finished printing for the day.

Simon Brett *observes that engraving is a subtractive process; he states, "The surface is cut away. A remainder stands proud. With overworking, this surface simply disintegrates and there is nothing left to bear the ink meaningfully at all." His print attests to this belief: he has left much to our imaginations in the faces of these lovers. They are mainly shadowed in black, with the highlights engraved out to pique our interest.*

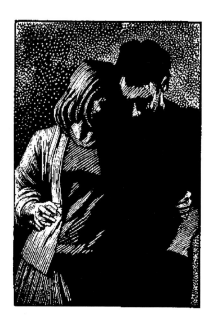

Lovers. 1999. Wood engraving; 2″ x 3″

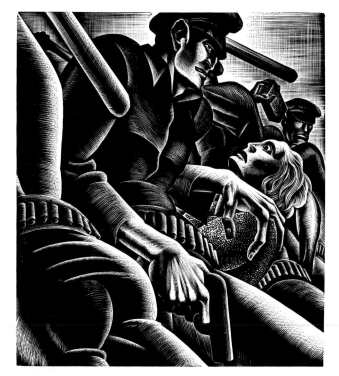

Lynd Ward, *the great American master wood engraver, created images that condemned political oppression and human greed.* From *Wild Pilgrimage,* a novel in woodcuts. 1932. Wood engraving; 4.5″ x 5″

And finally, you will want to give some thought to setting up separate storage areas for inks, oils and solvents; paper and board; and blocks and tools. Paper should be stored flat in a file cabinet or on shelves. Inks, oils and solvents should be kept in a steel cabinet or a fire-safe cabinet specifically made for storing solvents. For easy access, store blocks, tools, and rulers and pencils in labeled boxes on shelves.

MAKING THE DRAWING

If you have complex images in mind for your first block, put them aside for now. A simple abstract drawing is best for an initial attempt at woodcut or engraving. It will free you from the constraints of representation and make it easier to practice with the tools, exploring the different marks they make. Drawing a grid on the block and trying a different pattern in each section is another good exercise for the beginner. This sample block will give you a palette of textures, tones and patterns that you can incorporate into later work.

Many artists draw directly on the block, using a soft 3B pencil on wood or linoleum, a soft graphite pencil on Resingrave, and a CD-R pen or similar permanent marker on plastics. Other artists begin their work on paper and then transfer the image to the block. Although a computer cannot make up for an inability to design or conceive unique ideas, its drawing and paint programs can be used to manipulate scanned images, to create white-line images or to invert black-line images into white-line art. Whatever method you pick, remember one thing: *the drawing must appear as its mirror image on the block.*

If you choose to draw directly on the block, use a mirror to check the image for balance and proportion as you draw. Take care not to press too hard with the pencil, because too much pressure can cause indentations in the block that may show in the final print.

After I've worked out the pencil image, I draw over the artwork with black waterproof drawing ink or with a waterproof black marker. This is done for two reasons: pencil can smear while you are cutting

the block, causing the loss of part of your design, and inking the block makes it easier to see your lines against the color of the wood surface. Rather than trying to imitate the marks the woodcut or engraving tools will make on the block, I use a kind of shorthand. For example, I'll draw several parallel lines in an area where I'll be using a multiple-line tool, or some dots in a background where I'm going to make a stipple of white dots using a roulette wheel or awl. This method leaves room for the image to evolve during the cutting process.

If you choose to work out the image on paper, you can transfer it to the block in several ways. One way is to use carbon paper or a 6B graphite stick. First the image must be flipped so that it appears backwards on the block. To do this, place the drawing facedown on a light table, trace the artwork through the back of the drawing, and then rub soft graphite stick on the right-reading side. Tape the drawing graphite side down to the block. When you again trace the image, its mirror image will be transferred to the block. Don't forget to ink your transferred drawing; otherwise, the graphite stick will rub off while you're carving the block.

Photocopies of drawings and photographs can also be transferred to the block. To do this, first rub the block with a rag lightly soaked in acetone, estisol or wintergreen oil. Place the image, toner side down, on the block and dampen the back of the paper with the rag. The acetone softens the toner, transferring the image to the block when pressure is applied. To apply pressure, use a printing press or burnish the back of the acetone-brushed paper with a metal spoon. Be sure to do this in a well-ventilated area and wear gloves and a respirator mask with organic vapor filters. Not all toners work — older photocopiers seem to work best — so you will need to do a test first.

 You can also transfer toner-based copies, including computer laser prints, with a colorless blender marker. Blender markers containing xylene must be used with adequate ventilation and a respirator mask, because the vapors can be harmful. Tape the photocopy face down onto the

block, then rub the marker onto the paper until the image has been transferred. Since toner is heat sensitive, laser prints and copies from older photocopiers can also be transferred with an iron.

To transfer images printed from an ink-jet printer, first print the image on a thin Japanese *washi* paper. Next, cover the surface of the block with a thin layer of wheat paste. This simple paste is made by blending about a cup of white flour and a little water in a saucepan over low heat until smooth. Slowly add just under two cups of cold water and continue stirring constantly until the mixture thickens. Remove the pot from the heat, cover and allow to cool.

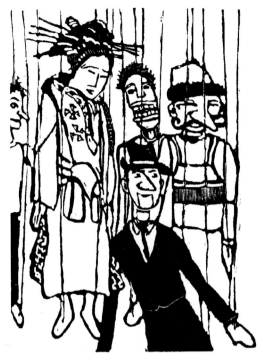

George Walker. *Marionettes.* 1997. Wood engraving; 4.49″ x 5.87″

Gently lay the *washi* paper onto the surface of the paste-covered block, carefully smoothing out any lumps. Don't use too much paste or the ink on the paper may bleed. The paste may take a few hours to dry, so don't expect to start carving through the paper immediately. When it does dry, simply cut through the paper into the block. Remove the paper and glue afterwards with water and a soft scrub brush.

Don't expect a perfect transfer with any of these methods. A successful transfer is one that leaves enough of the image to allow you to trace over the lines with a black marker or waterproof ink.

Check your work in a mirror one more time before you begin cutting the block. Is it art? When asked that question, Andy Warhol replied, "Art? Isn't that a man's name?" Once you — and only you — are satisfied with the image on the block, then you're ready to start cutting.

Jim Westergard's *"Loose Mask" is engraved on Micarta, a synthetic substitute for ebony. "I enjoyed the challenging experience working on it. I worked without a preparatory drawing, and I was pleasantly surprised to find the engraved lines turned lighter in value than the unengraved surface. The result was a block surface that resembled the white-line nature of the finished print."*
Loose Mask. 1994. Engraving on Micarta; 4.75" x 8"

Deborah Mae Broad *uses a litho press with a scraper bar and tympan to print her blocks. After screen printing her background she dampens the paper and prints the engraving over top. She prints her blocks with oil-based ink over acrylic screen-printing ink. To avoid registration problems when the paper stretches, she calenders the paper by prestretching it in her litho press.*
Success II. 2000. Wood engraving printed over screen-printed background; 5" x 7"

CUTTING THE BLOCK

Finally you're ready to cut! Your block has an image drawn on the surface, your tools are honed to perfection, and a bench hook or sandbag is in place to protect your hands. Don't forget to remove any rings, watches or bracelets that may accidently bruise or dent the surface of the block.

Everyone has different sized hands and varying levels of strength and dexterity. The best way to hold the tools for one person may be uncomfortable and unnatural for another. The most important point to make about holding any tool is to do it in a safe manner and in a way that allows you to cut easily without undue strain on your wrist, arm or hands. Remember, you're not digging holes; you're cutting white lines of various widths and shapes.

Never put your non-working hand in front of the cutting path of the tool. This may sound like common sense, but when you are concentrating on cutting a fine line, it's easy to forget. Most injuries occur when the block is being held in front of the tool's path. To prevent accidents, always use a bench hook. Then if you do slip, the gouge or the tool's blade will go into the bench hook, not your hand. Keep the block raised on a sandbag with the hand holding the block below the tool's cutting path.

Using the Woodcut Tools

Unlike wood engraving tools, which are always pushed through the surface, some woodcut tools are pulled and others are pushed.

The knife is drawn toward the body. When using either a Japanese or X-acto knife, grip it in your fist with your thumb over the top of the handle. You can use the forefinger of your other hand to steady and guide the blade, but this often causes beginners to cut themselves because they haven't yet developed the control that comes with experience. Other knives have long, narrow handles and are held like pencils.

To create a line that will print on paper, the artist must cut parallel "white" lines on either side of the drawn line. These white lines will determine the shape and appearance of the black lines in the final printed image.

The first step in creating a woodcut or linocut is to outline the image with a knife. Tone and pattern are used to form the inner part of the image. Hold the knife at a 45-degree angle to the block and about $1/8$ inch away from your drawn line. Make a cut not more than 2 inches long. Don't try to force the knife deep into the block. A light first cut will give you a guide to follow if the cut needs to be deeper. The depth of the knife outline should be between $1/16$ and $1/8$ of an inch. Switch the knife to the other side of the line, holding it again at a 45-degree angle. Aiming at the bottom of the first cut line, make another 2-inch-long incision. Your angled cuts should meet at the bottom, releasing a 2-inch-long sliver of material. The wood should lift out easily, leaving a V-shaped grooved channel — the white line around the image.

Using the knife

Cutting angles

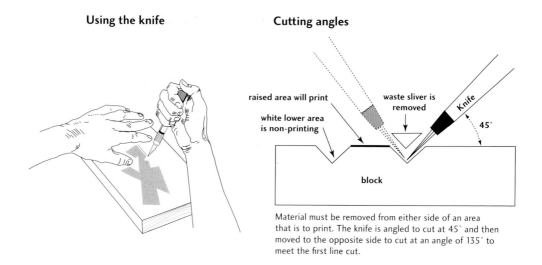

raised area will print

white lower area is non-printing

waste sliver is removed

Knife

45°

block

Material must be removed from either side of an area that is to print. The knife is angled to cut at 45° and then moved to the opposite side to cut at an angle of 135° to meet the first line cut.

Lines are cut by stitching small cut lines together to create one long line. A long, light first cut can be made to act as a guide as you stitch deeper cuts together over the distance of the line. Keep the angle of your knife at 45 degrees to the block as you stitch. Angles steeper than 45 degrees

on either side of your printing line make the line too weak to withstand the pressure put on it during printing.

Holding the gouge

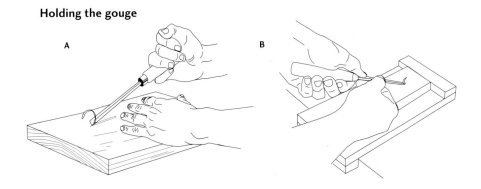

A

B

It takes a bit of practice to do this well. The knife has a tendency to follow the grain of the wood, but you learn to control the knife and make it cut where you want it to cut through practice. Those fluid lines you see in David Moyer's wood engraving (see page 100) and Christopher Hutsul's linocuts (see page 62) look as though they were made spontaneously and quickly, but in reality they were made with a slow, steady, careful hand.

Gouges and parting tools are pushed through the block to remove material in areas you don't want to print and to make rounded or tapered lines. If they have mushroom-shaped handles, they are held in the same fashion as engraving tools. If they have long, thick handles, they can be held between the ring and index finger in a type of fist (see illustration "A" above) or they can be held like a spoon with the thumb aligned with the shank of the tool (see illustration "B" above). Tools with narrow, slender handles can be held like a spoon as well. While one hand holds the tool, the other holds the block behind the path of the tool.

Many artists hold gouges and parting tools with two hands. One hand acts as a guide and the other grips the tool. Although this method is more commonly used with the larger tools, it can also give you additional control with smaller tools. Using both hands to push the tool through the block has the added advantage of keeping your hand

Mary Paisley *lets her tool marks add expression to this print outlining her hand. She has left the grain of the wood visible, which adds tone as well as a sense of character to a basic concept.*

Anna Mae Aquash Brave Hearted Woman. 1992. Woodcut; 5.75" x 8"

José Guadalupe Posada's *wood engravings are easily recognized because they have been reproduced on T-shirts and coffee mugs all over the world. Posada's skeletons are associated with the Mexican Day of the Dead festival. Because of the rich contrasts possible with wood engraving (and Posada's influence), skeletons have become a favorite theme with some engravers. This image was engraved on type metal (80 percent lead) and printed from the relief.*

Calavera de Artistas y Artesanos. c. 1887. Relief engraving on metal; 3.82" x 7.75"

out of the blade's path. However, because both hands are pushing the tool, you will need to stabilize the block with clamps or a bench hook.

Cutting curves is sometimes challenging and may require you to turn the block while you are cutting. You'll find it easier to follow a curved line with the gouge or parting tool if you outline it first with the knife. The Speedball Linozip is a useful tool for cutting curves. Like the knife, it allows you to use your wrist to control the cut. Since the Linozip is pulled toward you, the block can be turned with your other hand as you pull the tool through the surface. This tool is also easier to control if you first cut a light guide line with a knife.

After you have outlined all the image areas, you can start to clear areas that you don't want to print. There is a simple rule to follow in relief printing: the farther the distance between two peaks, the deeper the valley between them must be. Lines that are close together can have shallower valleys than lines that are farther apart. Large areas that you want to be stark white in the print should be cut deeply enough to avoid being inked. Usually a trial proof will show if an area has been cut deeply enough or not.

For clearing large areas, use both the gouge and the chisel. First, cut parallel grooves in the area you wish to remove with the gouge, going up to, but not into, your outlined image. It is safer to make these grooves progressively deeper rather than to make single deep cuts. Several cuts give you more control, enabling you to stop at the outline without fear of cutting into the image area. The chisel is used to remove the peaks left by the gouge. Many artists prefer to leave these peaks when clearing spaces. They use them to add energy to their images.

You can use sandpaper to lower areas that you don't want to print or to create smooth areas that print solid flats of color. The tiny scratch marks left behind by coarse sandpaper can also be used as a technique to create lighter areas or tiny white lines.

Using the Wood Engraving Tools

Because most of the wood engraving tools have the same mushroom-shaped handle as that found on woodcut tools, they are all held in much the same way. Engraving tools are pushed through the surface of the block, so it is important to use your palm to control the tool. Grip the tool comfortably in your lower palm with the thumb and forefinger holding the shank and the cutting edge extending beyond your fingers. To maintain good control, the blade should not extend more than half an inch beyond your thumb (see illustration page 81).

Some engraving tool suppliers will adjust the length of the shank or handle of their tools to fit your hand if you send them a photocopy of your hand. To shorten the tang on an engraving tool yourself, place the tool in a vice and gently tap the handle off. Cut the tang to the required length with a hacksaw, then file it to a point and tap the handle back on with a rubber mallet.

Again, remember that in relief printing you are looking at white lines, not black ones. The image is entirely made with white lines. Some artists begin by outlining the image with a graver or spitsticker. This technique has been used in the print of the train on page 82. The outline makes a groove that prevents tools used later from slipping into the image area. This is a good technique if you are having trouble stopping at the end of your lines.

Other artists cut white lines up to the contour of their drawing to define its edge. This effectively creates a black line around the image. Take a look at the Barry Moser print on page 66. The image appears to be outlined in black lines, but this is an illusion created by white lines ending at the contour.

Gently scratching your first lines into the surface creates a channel that your tools can follow with more control later. You can then go back into those lines and make them deeper, wider or more tapered. Never try to cut a long line in one sweeping motion; instead, stitch the line by making a series of short lines.

If you find that your hand shakes while you are cutting, it is probably because your arm is not supported properly. To steady your hand,

Holding the tool

Holding the block

Cutting angle

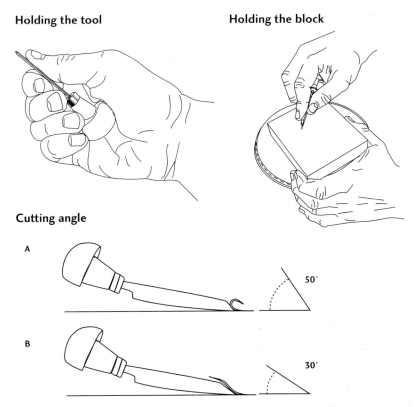

A

50°

B

30°

Tools sharpened with a steep face angle (A) tend to curl the wood being removed in front of the tool. This makes it harder to see the lines you are cutting. Holding the tool at an angle of 30° (B) allows the sliver being removed to curve over the face of the tool.

support your wrist or forearm with a stack of books or a cushion. When you engrave curved lines, turn the block on the sandbag and keep your tool hand relatively stationary. It's best to have the block at chest height so that you can keep your back as straight as possible while working. Take your time, there's no need to rush.

Barry Moser uses the spitsticker for his first cuts and then goes back into those lines with a scorper (round graver) to clean up the edges and define their taper. Look closely at his print on page 66 and you'll see how his white lines taper from thick to thin. Moser says, "My tools of choice are the spitsticker and the round graver, which I use to re-enter the lines cut by the spitsticker to widen them to invent a varying tonality. I also use the round graver to do stippling, and

Steps in making a wood engraving

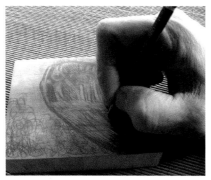

1. Drawing the image in pencil, then inking it in.

2. Engraving details with hand tools.

3. Chalking the lines for clarity.

4. Using a Dremel for a background effect.

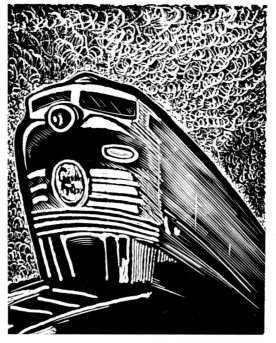

5. Finished print.

George Walker. *Train*. 2005.
Wood engraving; 3.75" x 4.625"

often use it — wagging it back and forth on either side of its vertical axis — to make lines that 'stutter,' and to vary the width of the line in a manner that the spitsticker cannot..."

When using the graver to make tapered lines, be aware that the deeper this tool is guided into the wood, the wider the line becomes. If you drive the graver too deeply into the surface, it will freeze. To create a tapered line that starts thin, widens, then thins again, engrave two lines from opposite ends of the imagined line so that the thickest parts of the two lines meet in the middle. If you try to make a line thinner at the end of a single stroke, you are more likely to slip and lose control.

Before cutting lines or clearing spaces close to areas with delicate engraved lines, many engravers use a thin 1- to 2-inch-square piece of card or a thin metal disk called a "planchet" to protect the finished block surface from tool bruising. It is also not uncommon for engravers to wrap the work they have already completed in kraft paper to protect it from their sweaty hands while they continue to engrave new areas.

Sometimes, on a dark wood like maple, it is difficult to see the lines you have already engraved. To help me see them, I rub chalk or talc into the lines so that they stand out (see illustration page 82). I remove the chalk later with a soft brush. You can coat a Resingrave block with a wash of India ink to make it easier to see your cuts. The white epoxy surface will show through the ink as you engrave.

As in woodcut, lines that are close together can have shallower valleys than lines that are farther apart. Most engravings are cut to a depth of $1/16$ inch. You rarely need to make a cut deeper than $1/8$ inch. Cuts deeper than $1/8$ inch are only seen on blocks with an inch or more to clear between raised printing surfaces.

Clearing large areas is done with a scorper and a flat graver. The scorper is used to make multiple lines close together and the flat graver is then used to remove the ridges between the lines. As you work, brush out the debris from the areas you have cleared with a soft artist's brush or toothbrush, so that you can see what you are doing.

You can also clear spaces and engrave small lines with a power engraving tool that has a flexible shaft. I use the Dremel number 105 ball-tipped bit for cutting small details and the 106 and 107 ball-tipped bits for clearing areas and making wider lines. The ball tip lets me move the tool more freely than the 109 and 110 flat-tipped heads. However, the 109 and 110 are better than the ball tips for making tapers and corners. Set the tool on higher speeds when carving hard woods and slower speeds when cutting plastics, since plastics tend to melt at the higher speeds. Increase the speed if the bit starts to chatter on the surface and always blow the dust away from the tool as you cut.

On Resingrave blocks, I find it easier to remove large amounts of material from areas that I don't want to print with a rotary tool.

Flexible shaft and rotary tool bits

107	106	105	110	109	113
3/32"	1/16"	1/32"	5/64"	3/32"	1/16"

CREATING TONES AND PATTERNS

Learning what marks the tools make, mastering the cutting of lines, and understanding how tones and patterns create depth and interest are the keys to woodcut and wood engraving success.

Grays, for example, give more emphasis to the blacks in an image. They are created either by lowering certain areas with a scraper or sandpaper, or by breaking up the solid black with engraved patterns, dots or lines. Lowering the surface must be done in a very patient, incremental way, since the thickness of a hair can make a difference

in how dark the blacks will print. You must take care not to remove too much of the surface or the lowered area will not print at all. This method works best when you are printing on a press. If you want an area to appear lighter in an image that you intend to hand print, simply use less pressure when you burnish the paper in that area. You don't need to lower the area on the block itself.

Patterns and textures often form the inner part of an image. Learning how to create patterns that tell viewers they are looking at skin or hair, for instance, requires a careful examination of how light reflects off these surfaces (see illustration below). A good way to practice cross-hatching, stipple, dotted, random and parallel line techniques is to try out several different sizes of tint tools and gravers. You can also have fun creating tones with lining tools.

George Walker. *Bill Poole*. 2001. Wood engraving; 3″ x 4″

REPAIRS TO THE BLOCK

Unfortunately, you can't be fearless and not make mistakes. So what do you do when your tool has found its way into an area where it's not wanted?

A small bruise or dent on an end-grain or plank block can be repaired by lightly sanding the area and then soaking it with a few drops of water. Allow the first drop of water to be absorbed into the surface, then follow with further drops until one drop remains on the surface over the dent. Light a match, hold it over the drop and boil the remaining water off. Be careful not to burn the wood! This should swell the cellulose fibers in the damaged area and make it level again. You might have to do this several times before the wood swells enough to repair the damage.

If your tool has slipped out of control and made an unwanted cut in the block, you can cover your trail by incorporating the line into

George Walker. *If I only had time to write.* 1985. Wood engraving; 3″ x 3. 875″

the image. If this isn't an option, as a last resort you might have to drill out the offending part and insert a plug. (This works better on end grain blocks.) To do this, you will need some doweling made of the same material you're carving and a drill bit to match the size of the dowel. A tapered plug will give the tightest fit. Drill about half-way into the block and insert the piece of dowel into the hole with a small amount of carpenter's PVA glue. You might need to tap the plug gently with a hammer. Protect the rest of the block with several layers of masking tape before cutting away any excess plug with a fine saw. The next part isn't easy either. You must try to level the plug with sandpaper. Even with the best effort, the plug may still be visible in the final print.

Another technique can be used to repair shallow scratches and dings. Auto body scratch and finishing putty (not the body filler used to repair dents) can fill the finest of scratches. Follow the directions on the tube and finish your repair with a very fine sandpaper. You can use wood filler too, but I find it crumbles and doesn't hold well in small scratches.

Resingrave can be repaired with epoxy, which can be purchased at any hardware store. Epoxy works better on small scratches and dings than on deep cuts.

Unmounted linoleum can be repaired by cutting another piece of lino to fit into the damaged area. Cut out and remove a shape around the damaged area that follows the contours of your image so that the replacement piece will not be conspicuous. Use PVA glue to attach a sheet of bond paper to the backing of your lino. The repair space should now have paper showing where there used to be lino. Outline the replacement shape in the new piece of lino, then carefully bend it to break it through to the burlap backing. Cut through the burlap with a knife. Now glue the replacement piece onto the paper backing on your original block. If your lino is mounted, you can try to remove the dam-aged area with the burlap backing intact by carving it out with a chisel and gluing in a new piece of lino.

PAPERS AND INK

PAPER'S COLOR, weight, surface texture and permanence all affect the quality of the finished print. Given the innumerable types of machine-made and handmade paper available, it is not an easy task to select one. Your choice of paper will largely depend on whether you are going to print your block by hand or on a printing press.

The best papers for burnishing prints by hand are thin, strong, soft and smooth. They should also be lightly sized. "Sizing" refers to the binder that is added to a paper to make it less or more absorbent. An example of unsized paper is toilet paper, which breaks apart almost instantly in water. You can tell how much sizing is in a paper by how waterproof it is. Take a sheet of paper and dampen a corner with a sponge lightly soaked in water. If the water soaks into the paper quickly, the paper is lightly sized; if it takes some time to soak in, the paper is moderately sized. With too little sizing, the strength of the paper and its resistance to ink bleeding and show-through are compromised. A large amount of sizing produces an almost waterproof paper. This may be useful for printing fine details but detrimental if you plan to use inks that dry by absorption or if you intend to incorporate some ink bleeding into your design.

If you are printing on a press, you have more options. The press can print images on thicker papers and papers with a slight texture. Avoid such papers if you are burnishing prints by hand unless you want the texture of the paper surface to show in the final print.

Because high quality paper is expensive, most artists proof their

images on cheap paper before printing them on the good stuff. Commercially available newsprint or bond paper is suitable for proofing. However, if you are looking for a better-quality proofing paper, art supply stores sell rolls of machine-made mulberry paper made in Asia. This paper, which is commonly used for brushwork, is also called shodo practice paper, sumi, kami calligraphy paper, India paper and rice paper. Now the confusing part: some art supply stores sell "India paper" or "China paper" that is not mulberry paper. These terms are left over from 19th-century European printmakers who prefaced anything from Asia with the words "India," "China" or "rice." Rather than mulberry paper, you may end up buying a thick manila paper or a mingeishi craft paper. However, many artists have successfully used these papers as proofing paper, so whether the paper you buy contains mulberry or not is unimportant.

George Walker. *Sita.* 2003. Wood engraving; 3″ x 4.75″

Alan Stein *did this wood engraving to commemorate 25 years of the Poole Hall Press. Bill Poole was a great influence on me and many other artists. The engraving accompanied a poem Alan Stein printed as a broadside on his Chandler and Price clamshell platen press. This print shows how effective the white line can be. Compare it with David Moyer's arresting black-line image on page 100.*

Bill Poole Anniversary Engraving. 1997. Wood engraving; 3" x 4"

Jim Horton *is an engraver and teacher. His tireless work with the Wood Engravers' Network furthers the appreciation of the art of wood engraving. You can tell by the wood engraving here that he has had fun playing with the possibilities of white space and black line in this image of an invented insect inspired by Darwin.*

Humbug. 2001. Wood engraving; 2" x 2.75"

The point of a proof paper is to give you some idea of what your image will look like when it's printed on your good paper. Don't spend a lot of money on proof paper, but look for something that has similar characteristics to the image paper you plan to use.

MACHINE-MADE PAPERS

Paper manufacturers make two types of machine-made paper: art papers and mass-market printing papers. Art papers for drawing, watercolor and printmaking are usually superior to the mass-market variety. Made in huge quantities to feed the printing industry, the latter are seldom archival quality and will disintegrate over time. Although they are cheaper than handmade papers and machine-made art papers, mass-market papers are better suited to printing on a printing press than by hand.

The paper grain of even art-quality machine-made paper may present a problem. The cellulose fibers all align in one direction, usually "grain long," which means along the length of the sheet. This is immediately noticeable if one side of a sheet gets wet: the paper will curl in the direction of the grain, forming a cylinder. If you intend to fold machine-made paper, it tends to break across the grain.

Machine-made paper is classified by weight, caliper, opacity, color and finish. The weight is measured in pounds per ream (500 sheets) of paper in the United States, and in grams per square meter (gsm) elsewhere. For example, the average photocopy bond paper is sold in packages of 500 sheets of 8.5 x 11 inches (216 mm x 279 mm) with a weight of 20 pounds. Another common measure is the M weight, the weight of 1,000 sheets. To convert the poundage weight to the M weight, simply double the poundage figure.

The thickness of paper is expressed in point sizes and is called its caliper. It is usually measured in thousandths of an inch. A sheet 10 points thick (0.010 inch) is about as thick as a business card.

The most confusing thing about buying commercial machine-

William Rueter's *engravings for his private press book,* Italian Landscapes, *show how a triptych design can add a sequential element that animates the scenes depicted here. The images have a connective relationship, with the two trees on either end trapping the center scene. Rueter engraved these blocks on maple and printed them on Mohawk Superfine paper with a mixed color using Van Son rubber-based inks.*

Tuscany. 2001. Triptych wood engraving; 3″ x 6.75″

Ralph Steadman *has a 400-year-old tree in his garden with a girth of more than 18 feet. He says, "Human beings love wood for all sorts of deep primeval reasons — shelter, warmth, buildings, weapons, natural sculpture, handles on tools, sacred icons, old oaks, time passing in rings and the natural beauty of wood polished through generations of use." Wood is part of our collective history.*

Wood Fragmented Monoprint. 1966. Woodcut; 18″ x 24″

made paper is that the numbers and names change dramatically, depending on where the paper was made and the type of paper it is: Book, Bond, Cover, Bristol, Index or Tag. For example, a 30 lb. Book paper from one manufacturer can be the same as a 12 lb. Bond paper from another manufacturer.

If you plan to mount your work, the opacity of a paper is important. If the paper is too thin, the color of the mat will show through, changing the color of the print. Cards or pages for a book also require opaque paper. A paper's opacity is expressed as a percentage. A sheet that is 100 percent opaque is completely lightproof but would be too thick for hand printing. The opacity of a paper can be tested by placing a piece of black card behind the sheet. If you hold the two up to a light, you will usually see the black card through the paper, but if you hold the two without back lighting, the black card may not be as visible. This is a general test for opacity and can help determine how much show-through you will get when you print on a particular paper.

The materials and chemicals used in the manufacture of a paper will affect its color or whiteness. Recycled papers are always duller and sometimes have a speckled appearance. Many mills add optical brighteners and other chemicals to produce a variety of whites from cream to brilliant white. Colored papers can affect the way your image will read. If the color is too dark, your image will be lost; conversely, if it is too bright, your image may look garish, but then again, that may be what you want.

Look for papers that are neutral pH or acid free. The pH of paper is measured on a scale of 1 (very acidic) to 14 (alkaline). A pH reading of 7 is considered ideal. The term "acid-free paper" generally refers to rag papers that are archival quality and pH neutral. To test the pH value of a paper, I recommend using a special pen sold at art supply stores. The chlorophenol red indicator in the Abbey pH Pen reacts with the paper to give a pH reading. Simply draw a line on the paper and read the result when it dries. A yellow mark means the paper is acidic, while purple means it is neutral or alkaline.

All machine-made rag art papers are neutral pH. My favorites for

printing on a press are Arches Cover, BFK Rives, Somerset, Rising Art Print and Stonehenge. Most art supply stores carry them. They are on the thick side (190 gsm to 300 gsm) for hand printing unless you print them damp and are prepared to burnish rigorously.

Most machine-made papers intended for the commercial printing industry are made of wood pulp. The high lignin content in wood-pulp papers increases their acidity and weakens them over time. However, innovations in the industry have led to the production of higher quality, neutral pH papers suitable for fine printing. Recycled papers and new types of bond paper are also stronger and more durable than in the past. Having said that, I've found that some of my best impressions have been made on the machine-made paper with the least longevity. Newsprint takes wonderful impressions from the block. Alas, it is not permanent and probably never will be.

Coated paper stocks are sometimes referred to as art papers because they are excellent for reproducing full-color images on high-speed offset presses. Because coated stock is smooth, it holds very fine details well and prints wood engravings sharply with rich blacks in the flat areas. Unfortunately, most coated stocks are not neutral pH and eventually turn yellow around the edges.

Machine-made papers are sold in a variety of finishes. Laid papers have parallel lines running across the sheet, while wove papers are free of these lines and have an even, smooth surface. Paper manufacturers can further finish a paper by calendering it between smooth cylinders or by embossing it. Textured papers tend to be difficult to print because the laid lines or other textures can prevent a solid impression. Watermarks can also be annoying. If you print over them, they will show through the thinner paper in the watermarked area.

Ideally, a sheet of machine-made commercial printing paper suitable for printmaking should have a neutral pH and be between 40 and 60 pounds in weight, lightly sized, hot pressed, wove, and cotton linter or flax (linen) based. There are exceptions to this rule. If you are printing on both sides of the sheet, a more opaque, thicker Book or Text type paper is a better choice. Despite the cautions above,

machine-made commercial paper is not necessarily a bad option, particularly if you are printing on a press. There are many good machine-made art papers that are suitable for printmaking. With a little experimentation, you can find good alternatives to the more expensive handmade papers. Just keep in mind what artist William Rueter says about choosing paper, "Remember that the better the paper quality, the better the result, and the greater satisfaction for you and the viewer."

HANDMADE PAPERS

Handmade papers are available in a variety of colors and surfaces. Most have a neutral pH and last for years without acidic damage. Like many handcrafted products, they are usually expensive.

The best handmade papers are a joy to print on. Well-crafted paper is free of debris and the same thickness from top to bottom, with the fibers distributed uniformly throughout the sheet. These characteristics can be checked by holding a formed sheet up to the light. You should see the light cast evenly through the paper fibers with no patchy dark areas. Poorly formed sheets contain unpleasant surprises, including bits of debris that can damage the block during the printing process.

Handmade paper usually has a deckle, or ragged, edge on all four sides. The word "deckle" is derived from the German *decke*, which means "cover." This refers to the frame that goes over the mold and forms the ragged edge of the paper when it is removed.

Handmade paper does not have a grain because its fibers point in all directions. Three finishes are available: hot pressed (smooth), cold pressed (matte), and rough. The best handmade paper for printing wood engravings and woodcuts is a thin weight rag paper that is lightly sized, hot pressed, acid free, wove, and cotton linter or flax (linen) based. I use handmade paper from the Saint-Armand mill in Montreal. Their paper prints wonderfully on my Vandercook proof press.

If you have difficulty printing on a handmade paper, try dampening the sheets slightly to dissolve some of the size. This makes the paper more receptive to the ink. Be sure the paper is damp and cool to the touch, without any surface moisture, rather than wet. To dampen a stack of paper, spray a mist of water on every other sheet and stack them under boards. You should print on them within 24 hours to avoid mold and mildew.

Water and moisture are the enemies of wood engraving blocks. If at all possible, choose sheets of paper that do not need to be dampened. Unfortunately, this is often easier said than done. Handmade paper can vary in composition from batch to batch. To avoid color and caliper changes from sheet to sheet, try to determine whether the handmade paper you are buying was all created from the same pulp batch.

JAPANESE PAPERS

Of all the printing papers, Japanese papers are the most responsive to the block and ink, making them the easiest to print by hand. The Japanese call their handmade papers *washi* — *wa* means "Japanese" and *shi* means "paper." They are also known as *tesuki washi*; *tesuki* is the word for "handmade" in Japanese.

Washi are made with fibers from the bark of Japanese shrubs, particularly kozo (mulberry), gampi and mitsumata. The long, strong fibers of these plants make the typically thin *washi* very durable. In addition to the traditional plants, Japanese papermakers use abaca and straw as well as clays and decorative inclusions such as colored threads, gold flakes and flower petals. Because of the rigorous labor involved in the making of this beautiful paper, its cost is steadily climbing. The fact that many young Japanese papermakers are not continuing the tradition of making paper by hand exacerbates the problem of scarcity and high cost.

When you are buying *washi*, choose sheets without inclusions or large stringy fibers that might damage your block or leave white

halos around your printed image. To check the sheet for smoothness, gently rub your hand over its surface, feeling for any bumps that might interfere with your impression.

Washi are thin and very absorbent and are occasionally sized by hand before printing. A size made from gelatin, alum and water is brushed on the sheet and then left to dry. This reduces the amount of bleeding into the paper that occurs when Japanese water-based ink is used during the printing process. However, the best papers are not sized.

My favorite *washi* are made from the fibers of gampi, kozo and mitsumata. In the past, papermakers combined the long fibers of these plants to create papers with great strength, resilience and absorbency. However, the world demand for cheaper papers has forced some papermakers to add short-fibered wood pulp to the traditional Japanese fibers, resulting in papers that are heavier and less absorbent, though much less expensive.

Today the best quality *washi* is made solely with one of the traditional fibers. Paper made with gampi has an elegant sheen and a fineness that is excellent for printing woodblocks. Kozo paper is noted for its great strength, even when wet, which makes it a good choice for printing with water-based inks. Some artists print it damp and allow the ink to bleed into the paper, creating watercolor-like effects. Mitsumata (Japanese Imperial Vellum) is a fine quality, very absorbent paper with a creamy, almost buttery color. Unfortunately, it can be expensive and difficult to find.

Although I prefer to use *tesuki washi*, my friends at The Japanese Paper Place in Toronto have introduced me to some very good machine-made papers called *kikaizuki washi*. Their smooth, clean surface makes them suitable for proofing, but they are not usually archival quality.

To find out which of the many varieties of *tesuki washi* and *kikaizuki washi* work best with your images, I suggest purchasing a selection and experimenting for yourself.

INK

All inks are made from pigments or dyes, a water-based or oil-based vehicle that binds the pigments together, and additives. Whether you choose a water-based or oil-based ink is a matter of personal choice — the same choice painters make when choosing between oil paints and water-based paints. It largely depends on how you work and what you like to work with.

Inks are printed in thin layers that can be transparent, semitransparent or opaque. How an ink prints depends on the paper used. Its color will be affected by the paper's color, coating, sizing, absorbency and surface texture.

Oil-based and water-based inks can be purchased by the tin or in a tube. Tubes are more expensive but last longer because the ink doesn't form a skin in a tube the way it does in a can. When removing ink from a tin, use an ink knife (a putty knife works, too) in a level sweep around the surface. Never dig into the can. This causes the ink to dry out in the middle, which may result in small bits of dried ink showing up on the slab as you ink it and eventually on your print as "ink hickies."

Adjusting Your Ink for Better Performance

It's true that you can open a tin of block-printing ink and start printing with it, but where's the fun in that? Printmakers mix inks in much the same way as fine painters mix paints. They do it to create interesting colors and finishes, but they are also notorious for carefully adjusting the consistency of their ink to fine-tune its performance. It's like supercharging a car!

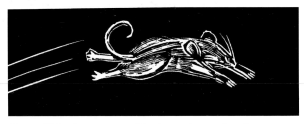

George Walker. *Leaping.* 2003. Wood engraving; 1.25" x 4"

An ink's performance is controlled by additives, while its tone and color are controlled by the amount of pigment in the ink. Since most artists do not make their own inks, they are stuck with the amount of pigment in the ink they have purchased. Higher quality, more expensive inks usually contain more pigment. With the exception of Japanese printmakers, who do mix their own inks, block printmakers do most of their mixing with ready-made printer's ink. They mix different colors of ink together and then add retarders or driers to slow or speed up the drying process, varnishes to change the finish, extenders to improve the body, or transparent base to make glazes and tints.

The vehicle in letterpress ink, which is the ink I use for printing wood engravings and woodcuts by hand or on the press, is usually oil-based. Non-Japanese water-based inks use a variety of vehicles, including resin polymers and acrylics. Retarders that lengthen the ink's drying time are available for both types of ink. Other additives hasten the drying process. Cobalt drier, for example, is a viscous purple liquid that speeds up ink drying by attracting oxygen more quickly to oil-based ink. No more than two drops are added to about a tablespoon of ink.

Good letterpress and block-printing ink is stiff but not rock hard and can be used for hand printing or with a press. Many lithographic types of ink are suitable for printing relief prints, but inks designed for intaglio printing and screen printing should be avoided. Although lithographic black ink usually needs little adjustment, colored inks may need additives to increase their tack (stickiness) so that details in the image don't fill in, or to decrease their tack so that open flats of color can be printed solid.

Printmaking varnishes are used to increase the ink's tack and viscosity. They can also be used to overprint an entire image or to provide a special finish to selected areas of an impression. Available in matte, semigloss or gloss, they are rolled onto a block and then printed. Because they have no color, varnishes affect only the finish of the print.

David Moyer *loves the black line. His finely printed, limited-edition works focus on his black and white wood-engraved line drawings. Many of his images have an abstract, fantastic quality. David is a fan of German Renaissance woodcut artists.* "I draw directly on the block using a combination of Crow Quill, mapping and a .25 technical pen. Layout is done in pencil, usually a cartoon only, though if I have text in reverse I will use a Xerox transfer for the text only."

A Speculative Reason. 2004. Wood engraving; 5" x 4"

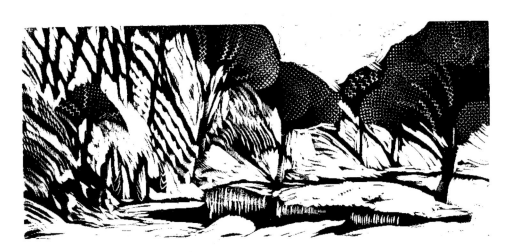

Brian Kelley *has experimented with textures from other surfaces. By pressing textured metal or plastics into the surface of the wood he can create marvelous patterns.*

Untitled. 1999. Wood engraving with leather tool marks; 2.5" x 5.75"

Extenders, which increase the volume of ink without lowering its viscosity, can be added to both oil- and water-based inks. They are used when uniform flat colors are desired. Paste is the extender used in the Japanese water-based method, while manufacturers of oil-based inks sell extender as an additive that is purchased separately. Magnesium carbonate and calcium carbonate are common powder extenders added to oil-based color but not to black inks. A syrupy liquid extender known as tint base extender will make the color more transparent than powder-based extenders. Too much extender added to an ink will cause it to lose its color intensity.

Reducers are another additive that printmakers use to adjust the thickness and viscosity of their inks. Mineral spirits and water are reducers but should never be used in the ink preparation process. However, a few drops of water or solvent can revive an ink that is too thick to use. A better solution, though, is to add a bit of linseed oil to an oil-based ink or gum arabic to a water-based ink. Reducers should be used in very small amounts, about 1 part reducer to 5 parts ink. Too much reducer destroys the ink's ability to adhere to the paper.

Transparent tint base (also called white base or transparent base) is added to ink to increase its translucency and to allow previously printed colors to show through a new layer, creating new colors in the process. The overprinting of multiple transparent glazes changes the finish of the print, making it more luminous and giving a glass-like appearance to the printed color. This is similar to the painting process called "glazing."

Oil-based Inks

Most oil-based inks dry by oxidation. This makes them highly suitable for printing multiple colors because they dry quickly between printed layers. If the ink tin label reads "no driers added," it is still an oxidizing ink, but you need to add driers for the ink to set properly. These inks will give you a reasonable working time (three to four hours); however, if you leave ink on your roller for an extended afternoon coffee break, don't be surprised to find it dry when you come back

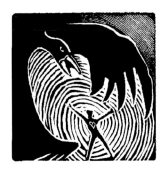

to it later. Unlike rubber-based inks, oxidizing inks do form a skin in the ink can.

I prefer oil-based inks over water-based inks for printing by hand or on the press. They give a longer working time, a richer black and a broader range of colors (although that is changing). Used straight out of the can, they may have a shiny finish. If you want more of a matte finish, products are available that can dull the shine.

To clean your rollers, ink slab and ink knife after printing, vegetable oil is a good substitute for mineral spirits or other solvents. It is a little more expensive, but much less toxic. Follow up with an ammonia-based cleaner to remove any remaining oil film. Using cotton rags instead of paper towels will cut your cleanup time in half.

Rubber-based Inks

Rubber-based inks, which are another type of oil-based ink, dry by being absorbed into the paper. They are a good choice if you like to work slowly and don't want your ink to dry on the roller, ink slab and press while you work. The fact that they don't form a skin in the ink can is a bonus. Avoid these inks, though, if you are printing several layers of color or printing on a coated, non-absorbent paper. After the first color is printed, each subsequent layer takes a few months to dry. That's a long time to wait for your ink to dry!

I use a rubber-based ink for proofing in black or for printing in a single color on handmade paper. To avoid ending up with a pile of prints that never seem to dry, always use an absorbent paper when printing with these inks.

Pro-Line PPI Ink

This new resin-based ink dries by polymerization. In this process, a chemical reaction transforms the molecules within the ink when the ink is printed. This means it will not dry on the press, roller, in its tin or on the ink slab. Mineral spirits are used for cleanup.

Water-based Inks

Printmakers use two types of water-based inks for block printing. They are premixed acrylic-based inks and Japanese water-based inks some of which are available as premixed colors.

Acrylic water-based inks have yet to prove themselves to me. They tend to penetrate the block's surface, swelling the wood. This causes fine details to disappear and contributes to premature cracking. Although remarkable progress has been made in producing water-based inks that behave like traditional oil-based inks, one major problem remains. Water-based inks tend to dry quickly. Most manufacturers add glycerine to retard the drying time, yet the ink still dries too fast, especially when the room temperature exceeds 20°C (68°F). Blocks printed with acrylic-based inks produce prints with a dull "plastic" finish, unlike the rich, velvety colors of prints made with oil-based inks.

Another option is a vegetable ink produced by the Graphic Chemical and Ink Company. The printed finish produced by this water-soluble, soy oil-based ink is much closer to that produced by traditional oil-based inks than by acrylic-based ones.

If you are printing by hand in a small space, or are sensitive to oil-based inks, water-based inks may be your only option. It is important to remember, though, that although it may seem that these inks are safer to use, the pigments they contain are still toxic.

Japanese block-printing ink, which is always water based, is made by mixing vegetable and mineral pigments with a small amount of gum arabic as a binder — one part binder to six parts pigment. A small amount of this mixture is then combined with rice paste (nori) and brushed directly onto the hardwood wood block. The key to successful inking is to balance the paste and pigment. Several factors determine the correct balance, including room temperature, type of pigment used and the absorbency of the paper. Too much paste will cause the paper to stick to the block, although one way to prevent this is to print quickly. Too little paste and the image will be speckled with dots of pigment. Many modern artists who practice Japanese block printing prefer not

to mix their own inks because ready-made Japanese inks are more convenient. They may also substitute tubes of watercolor and gouache for the pigment. Then they don't need to add the gum arabic because it is already there as a binder in watercolor paints.

Mixing Colored Inks

Mixing colors for printmaking is governed as much by personal taste as it is by the science of color and the chemistry of ink. For that reason, I'll suggest only a few color mixing palettes and leave it up to you to experiment with your favorite inks.

Let's begin with black. It's easy to forget that there are different shades of black. You can mix cool or warm blacks for subtle effects, or to create a rich deep black, you can add a small amount of red.

Most colors can be mixed using the primary process ink colors magenta, cyan and yellow. Magenta is a pinky red, cyan is a light blue and yellow is a very light yellow. Theoretically, if you combine these three colors in equal parts, the end result should be black but is actually a muddy brown. This is why you need to have black in your palette. Black allows you to improve the shades of the colors you mix and to print a rich black when needed. White is used to create pastel colors and to lighten colors that you want to remain opaque.

Process color inks work well with transparent tint base when you want to create glazing effects on your prints. Pantone mixing guides, which are available at art supply stores, can be used with process colors to create millions of different colors. By following the mixing formulas printed on the Pantone swatch book, you can match the printed samples.

Hundreds of artist-quality colored inks are available, but it's a good idea to begin with a limited palette. Here's a list of 14 basic colors to get you started: alizarin crimson, yellow ocher, viridian green, chromium oxide green, cadmium red medium, ultramarine blue, cobalt blue, cobalt violet, cadmium orange, burnt sienna, cadmium yellow, phthalo blue, cadmium yellow medium, phthalo green, process black and opaque white. With these colors you'll be on your way to experimenting with all the possibilities color has to offer.

You can also create your own inks by taking a can of white transparent base ink and mixing in a color using regular oil paint from a tube. The colors are transparent, but printing overlapping layers of the ink can create rich, luminous prints.

How to Keep Your Ink from Forming a Skin

Most oil-based relief printing inks dry by oxidation and need a barrier from oxygen to keep the ink surface from hardening. Some printmakers like to pour a layer of water on top of the ink in the can. However, because water has oxygen in it, the ink will eventually form a skin and the can may rust. A better solution is to use an anti-skin spray on the ink before putting it away for storage. This is available from most commercial ink suppliers, but if you can't find a local source, try using non-stick cooking spray.

Another good solution is to place a new piece of wax paper over the exposed ink surface after each use. You can also create an airtight seal by coating the inside rim of the ink tin with petroleum jelly. Or you can use a little trick suggested by Canadian artist Wesley Bates: find a lid from a smaller container that will fit inside your ink can. Drill a hole about 1/2 inch in diameter in the middle of the lid you've found. Then place this lid in the can and press down on it to extrude a fresh bead of ink. When the bead skins, you simply remove it and press down on the lid to extrude a new bead of ink.

Water-based ink forms a skin when the water-based vehicle evaporates. The best way to prevent this is to keep the ink in an airtight plastic container. I sometimes keep mixed colored ink in small packets of folded wax paper.

George Walker. *Embrace*. 1998. Wood engraving; 1.25″ x 3.75″

PRINTING

OU'VE CUT an image into the surface of your block and it's time to find out if it will make an impression — a good one, we hope! But before you begin printing, take a look at your workspace. Try to organize it so that you have separate areas for preparing the paper, inking and printing. Have all your supplies ready to go: paper, ink, ink knife, roller, baren or spoon (unless you have a press), masking tape, ruler and pencil. As for a dress code, old clothes, an apron with pockets, a hat to keep your hair out of the ink, and rubber gloves are all you need.

The first step is to prepare the paper. Make sure your hands and the surface you will be working on are clean. Cut the paper down to fit your image, leaving a margin of at least 2$\frac{1}{2}$ to 3 inches. The margin not only makes it easier to handle the paper during the printing process, but also gives the image a neutral zone so that the eye focuses on the image. You can either tear your paper to size with a straight-edged ruler or cut it with a guillotine or X-acto knife. Leave at least two straight edges to make registration easier. Place your unprinted paper in a pile beside where you will be printing.

In addition to the final print sheets, don't forget to cut at least 15 proof sheets (more if you anticipate a number of changes). You can still cut into the block at this stage, removing unwanted areas and making changes to the image. One of the great advantages of making prints is the ability to change the image as you work. Shape them as a sculptor would, removing a bit here and a bit there to reveal what is hidden within the wood.

Each time an impression is made, the image should appear in the same location on the sheet. To make it easier to register your image, choose paper with at least two square, straight edges and cut the proof paper and final print paper so that they are the same size. If your paper has deckle edges that you want to keep, you can make register marks by gluing or taping 1 x 4 inch paper tabs not more than $1/2$ inch into the edges of the paper; any farther in and you will lose valuable margin space.

To keep the paper clean while you are handling it, paper holders are a good idea. A tiny bit of ink on your finger will leave fingerprints everywhere if you are not careful. To make the holders, simply cut several 2 x 3 inch pieces of card stock (postcard thickness) and fold them in half. Talc rubbed into your hands is another way to keep your paper smudge-free. The talc soaks up any ink and prevents it from being transferred to the sheet. You can make a little cloth talc bag and put it in your apron pocket.

No rules govern how many impressions or how many changes to the image you can make. You may find that you like your early impressions more than your later ones. You may run off three or a hundred prints. Or you may change the image fifty times, then make an edition of five identical prints. The choice is up to you.

In our age of instant printing, the art of making exact copies of an image is no longer valued as much as it was in the past. Many artists still pride themselves on making exact copies and consistent editions of original prints. However, a growing number of artists are making variations in their editions on purpose to create individual unique prints from the same block. What is important to them is the creation of prints that convey the spirit and vitality of the art.

Woodcut artists create images with the tools of paper, ink and block in much the same way as painters use paint to build an image. For the printmaker, the printing process is an art in itself.

PRINTING BY HAND

Printing blocks by hand involves three simple steps: inking the block, placing a piece of paper over the block, and burnishing the back of the paper until the image has been transferred onto the sheet. With practice and an understanding of the mechanics behind the art, these steps can be mastered in no time.

The Roller and Ink Slab

Before you can ink the block, you will need a roller (also known as a brayer) and an ink slab. A good quality roller is made of urethane rubber and has a sturdy handle and a surface that gives slightly when pressed. Try to steer clear of old gelatinous composition rollers and

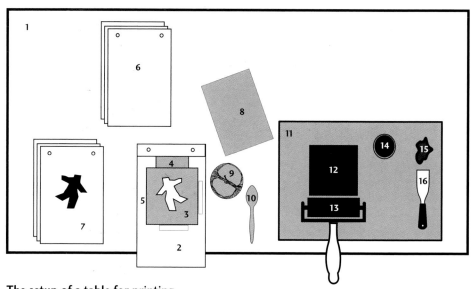

The setup of a table for printing

1. 30" x 60" table that is 30" high. **2**. Bench hook with registration pin. **3**. Woodcut with image. **4**. Spacer block (aka furniture) is lower than the printing block. **5**.Tape holding block in place. **6**. Paper ready to print with holes punched for registration. **7**. Printed paper interleaved with newsprint to prevent the image from offsetting. **8**. Mylar or scrap paper for burnishing on. This goes on top of the printing sheet. **9**. Baren for burnishing. **10**. Spoon for burnishing. **11**. Ink slab made of marble or plate glass. **12**. Rolled-out ink on slab. **13**. Ink roller or brayer. **14**. Can of ink. **15**. Ink from can, kneaded and ready to roll. **16**. Ink knife for removing ink from can and kneading the ink.

new leather rollers. The former are water soluble and easily damaged and the latter are used mostly in lithography.

Manufacturers of rollers refer to the hardness or softness of a roller as its durometer. This is expressed as a number ranging from 10 (soft), 30 (firm) to 100 (hard), depending on the compound used. A medium-soft rubber roller between 20 and 40 duro is recommended for relief printmaking. At this hardness, the surface of the rubber gives a little when you push into it with your thumb. If your block is not perfectly flat, this amount of "give" will accommodate any slight variations in the block surface. Avoid a roller made from hard rubber or plastic with a 70 to 100 duro surface. It will not have the flexibility to ink a slightly uneven block.

The roller should be slightly larger then the surface of the block. For small blocks I like to use a Speedball Deluxe soft rubber brayer, which is available in $1^1/2$- to 6-inch widths. Made of a natural gum rubber, it has a 20 duro ground finish. I also have an 8-inch-wide polyurethane rubber roller with a $1^1/4$-inch diameter and a durometer of 30, and a 6-inch-wide, 2-inch diameter old-fashioned brayer, which I had recast with urethane rubber at a local commercial roller refinisher.

Large hand-inking rollers, cylinders with handles on each end, are sold in a variety of sizes from 10 to 20 inches wide and from $4^1/4$ to 10 inches in diameter. A 10-inch diameter roller can ink 10 inches before having to be recharged. Although designed to ink litho stones, these rollers are ideal for printing large woodcuts and engravings.

Clean your brayer after every use. If you are using oil-based inks, clean it with vegetable oil. Wipe the roller first with a slightly oily rag, then wipe it down with a clean rag and a small amount of oil. After months of use, if the roller has a glaze on the surface from the oil, use a rag dampened with mineral spirits to clean it off. Large rollers can be rolled over a clean ink slab dampened with a bit of mineral spirits or vegetable oil and then wiped with a cloth rag. If you are using water-based inks, clean up with water and put a drop of light three-in-one oil into the axle of the roller after every four uses. Finally, store your rollers out of the way on a hook that is large

enough to prevent the roller from touching the wall. Never leave the roller in contact with a table or slab. The pressure can distort the surface.

After years of use rollers can lose their original finish. Glazed rollers can be resurfaced at a commercial roller refinisher for a nominal cost. If you have a commercial printshop in your community, ask the printers where they get their rollers refinished.

An ink slab is simply a clean, flat surface on which to roll out the ink. I use an 18 x 20 inch marble slab, but a pane of tempered plate glass, an old litho stone or a piece of plastic work equally well. The material should be heavy enough to prevent it from sliding when you roll the brayer back and forth on it.

Preparing the Ink on the Slab

To prepare the ink for printing, first remove a small amount from the can with an ink knife or putty knife. Remember, no gouging. Skim the ink evenly from the surface. Next, work the ink to make it soft by kneading it on the slab with the ink knife. If mixing colors, use a clean knife for each color. Put a bead line of ink across the top of the slab, then spread it out until you have an even, flat line.

Roll out your ink until it is uniform in consistency on the roller and on the slab. It is always best to start with a small amount of ink and then add more if necessary. To be sure that the roller is fully charged with ink, lift it and let it spin several times so that different parts of the roller contact the slab each time you roll. When the ink is neither too thin nor too thick, it will often make a high hissing sound as you draw the roller back and forth on the slab. Slow rolls across the slab collect more ink on the roller than fast rolls.

Inking the Block

The goal in inking the block is to place a thin, even layer of ink on the block surface. Too much ink will cause the fine lines in the image to fill in, creating a blotched print. Too little ink will create a light print that looks like a bad photocopy. A slow pass across the block with the

roller lays down more ink than a quick pass. Large surfaces are inked by making an asterisk-type pattern over the surface, starting from one corner and moving clockwise around the block.

Inking the block

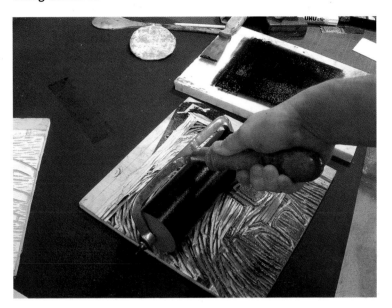

A quick proof of the block will tell you whether you need to add more ink to your ink slab or change your inking technique. For example, if one corner has printed lighter than the rest of the print, you may have missed that area with the brayer. Look over the surface of the block carefully to make sure the ink has been distributed evenly. Is it a good proof? This is largely an aesthetic choice based on how you want the image to print, which might be dark or light and, if you are using a wood block, with all or little of the wood grain showing.

Some artists deliberately roll uneven amounts of ink onto a block to create light areas on the print, or they may use several colored inks at once. They apply the ink at random so no two prints are alike. These prints are referred to as monoprints.

If you don't want the valleys in a woodcut or engraving to print as fine black lines in your white areas, be careful to ink only the top

peaks of the block. To make this easier, simple bearings (runners) can be used to guide the roller over the surface. Take two 1-inch-wide pieces of wood, the same thickness as your block but a little longer, and place them on either side of the block. A roller that is wider than the block can now ride on these side bearings, applying ink only to the uppermost surface of the block. Printing presses like the Vandercook proof press are designed with inking rollers on fixed bearings. They automatically ink only the upper surfaces of blocks.

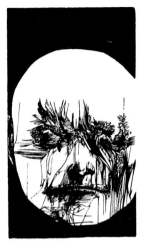

Leonard Baskin. *William Blake.* 1962. Wood engraving; 4″ x 2.75″

If you are using very absorbent paper and your block has never been inked before, you may need more ink than usual to make a dark impression. It is best to build the ink up on the surface slowly to allow the block to absorb the ink. Fixing the block to a printing jig with tape (see page 113) makes this easier. With a jig, you don't need to reposition the block every time you roll it up and you can avoid getting ink on your fingers.

With your brayer charged with ink and the block nearly ready to print, should you go and see a movie with a friend? Not unless you're using slow-drying rubber-based ink! Oxidizing inks can dry in only a few hours, damaging your roller in the process.

Making an Impression

Before you begin printing, it is a good idea to fan out your pile of printing paper to make it easier to pick up each sheet. Pick up the first sheet and, holding it diagonally at opposite ends, place it squarely over the block. If you are using a registration technique, align the lines on the back of your good paper with the lines on your printing jig. Or if you are using paper guides, make sure the paper is squarely in place against the guides. Now place a scrap sheet of letter-sized bond or newsprint over the printing paper. This is what you will burnish to prevent the impression paper from tearing or pilling.

I use a simple handmade jig to hold smaller blocks and for positioning my paper. Tape down the block with masking tape to the jig so that it doesn't move. With a pencil, mark registration lines on the jig and on the back of the paper. Rather than using a jig for registration, the

Japanese carve kento marks (see page 116) directly into their woodcuts. If you use the same size block all the time, you can do this as well.

Bench hook used as printing jig

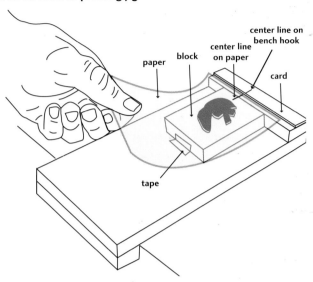

For burnishing, select a Japanese baren, a wooden or steel spoon, a tool called a folding bone (a tool for folding and creasing paper) and an etcher's burnisher or any other object with a blunt, smooth surface suitable for applying pressure to a small area. To begin, gently rub the paper so that it adheres to the block. Allow the natural tack of the ink, rather than your hand, to hold the printing paper, because pressure marks from fingers and palms can show through on the final print.

Japanese baren

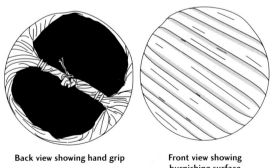

Back view showing hand grip Front view showing burnishing surface

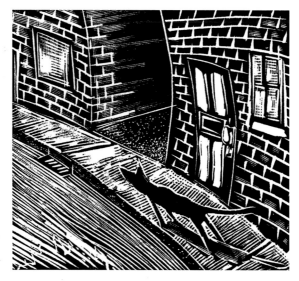

George Walker. *Curiosity.* 1998. Wood engraving; 3" x 2.75"

Rub evenly and firmly over the entire image area in a circular motion. If you are using a Japanese paper, you will be able to see the image emerge through the back of the paper as you burnish. With heavier paper, you will need to lift the corner now and then to check on the transfer of ink to paper. The amount of pressure used with the baren depends on the effect you are attempting to achieve. Light pressure, as you would expect, produces fainter lines and lighter tones than heavy pressure.

Are you happy with the printed image you can see from the lifted corner? Are the tones and lines printed to your liking? If the answer is yes, then the print is ready to be removed from the block. If it is no, you may want to burnish the print again or roll a little more ink onto the surface of the block while the paper is partially peeled back. However, adding ink is difficult to do without moving the paper off register or touching the paper with the roller. Try holding one end of the paper down with a paperweight and clipping the other end of the paper back with a paper clip while you re-ink areas. This is easier to do on larger blocks than smaller ones.

Once you're pleased with the impression, lift the printed paper by its corners in one swift motion away from the block surface. If the

prints have a lot of ink on the surface, they should be dried in the open air for 12 hours until the ink has had a chance to set. Printed sheets can then be stacked between newsprint for further drying and pressing. Do not stack them directly on top of each other; the image can offset onto the back of the sheet above it. You can also use a drying rack purchased from a printmaking supply store.

Dampened papers should be stacked between blotter paper (available at art supply stores) or paper towels and left to dry flat. Place a sheet of plywood on top of the stack to prevent the paper from buckling. If you are printing multiple colors, don't let the dampened paper dry out between colors or the registration will be compromised.

The most important thing to remember here is to relax, have fun and remember that it takes time to learn to print well. The best teachers are practice and patience. Give yourself permission to fail on your first trial runs and gradually improve your method to suit your style.

Color Printing

The most difficult part of color printing by hand is registration: ensuring that each block prints in the exact same place on the sheet every time. The only way to do this successfully is to use a registration system.

The Japanese system of registration uses kento marks, shallow grooves cut into the lower-right corner and bottom center of the block (see illustration page 116). The two notches are cut just deep enough (not more than $1/16$ inch) to allow the paper to sit in place without shifting. To make the center kento mark, cut straight down with a knife, making a line about $1\frac{1}{2}$ inches long. The two lines of the corner mark — each $1\frac{1}{2}$ inches long — are cut the same way. A chisel is then used to remove about $1/16$ inch of material from the inside edges of the lines cut by the knife.

Before cutting your kento marks, you must determine the margins of your paper so that you can position the marks outside them. Kento marks are only printed onto the paper when you want to transfer the marks to other blocks for carving additional colors. If you are printing one color, the marks are used for positioning the image squarely on the paper.

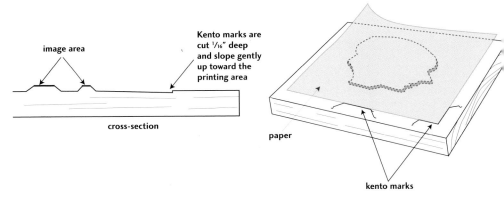

image area

Kento marks are cut ¹/₁₆" deep and slope gently up toward the printing area

cross-section

paper

kento marks

The Chinese registration system uses two stationary tables (see illustration below). The pile of printing paper is clamped to one table and the block is inked and positioned on another table. The sheets are flipped down in turn onto the block for printing. After a sheet has been printed, it is dropped into the space between the tables. A new block is positioned on the block table for each new color.

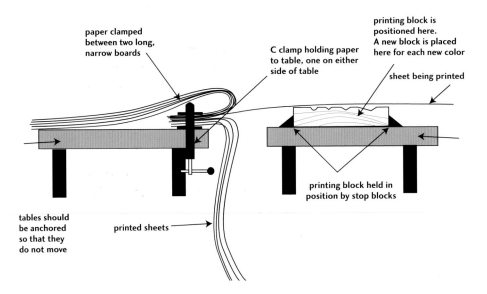

paper clamped between two long, narrow boards

C clamp holding paper to table, one on either side of table

printing block is positioned here. A new block is placed here for each new color

sheet being printed

printing block held in position by stop blocks

tables should be anchored so that they do not move

printed sheets

Some woodcut artists use a pin system for registration. Art supply stores sell metal registration pins or you can make your own pins from a piece of wooden dowel. The pins are stuck into the top of a printing jig (see illustration below) to line up with holes punched at the top margins of the impression paper with a standard one-hole or three-hole punch. After printing, the punched margin is removed.

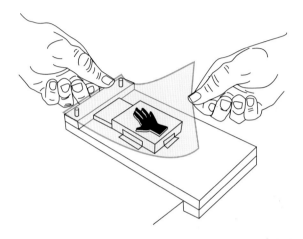

In planning a full-color woodcut, the first task is to work out your design and colors on a master drawing. Use the master drawing as a guide to determine where each color will print. Trace in black each separate color from the master onto new sheets of paper. This is the process of making color separations. These separations are then transferred (see transferring drawing page 72) onto multiple blocks for cutting. The key block is the first block to be cut and the last block to be printed. The key block is the black (darkest color) printing block. The printing order is usually from lightest to darkest color.

After the first color is printed (usually the lightest color, yellow), subsequent color blocks are registered by aligning the previous color printed with the key block. Print a proof of the key block on tracing paper so that you can see through the paper to the new block to align it. Once you've determined the position of the new block, affix the block to the printing jig with tape.

The two basic color printing methods are reduction block and multiple block (see pages 133 and 134). In the reduction process, you use only one block and cut very little of the image out before you start printing the first color. The master drawing is used as a reference and retraced onto the block after each impression so that you can see subsequent areas to be cut away. Start your printing with the lightest color and gradually cut away your image until you are printing the final, and darkest, color. Clean the block with a dry cloth after each color and, if possible, let it dry before printing the next color.

The disadvantage of the reduction method is that the block is destroyed in the process of making the print because each previously printed color is cut away. For example, let's take an uncarved block and print a flat yellow rectangle from it. Next we'll carve some lines on the block and print them using transparent blue registered over top of the yellow rectangle. What we'll now see is a printed image of yellow lines with a green background. We can't print the open flat yellow again because we've reduced the printing surface of the block. We then cut more lines into the block and print a transparent red registered over the blue and yellow printing. The final print has yellow lines, green lines and a brown background. Because of the cuts we've made, we can't go back and print the blue and yellow combination.

In multiblock printing, a new block is cut for each color. The first block that is cut is called the key block. Like the black outline in a coloring book, it carries all the details you want to see in the final print plus, in the Japanese method, a set of kento marks. The image and the kento marks on the key block are then printed in black onto thin *washi* sheets, one for each color block. These printed sheets are pasted face down onto the color blocks using the transfer method on page 73. The kento marks and the parts of the image that you want to print in a particular color are then carved into the block for that color, through the paper. When you are ready to print, begin with the lightest color and finish with the darkest one.

American artist Holly Greenberg uses a digital camera to take a photo of her subject, then brings this image into Adobe Photoshop

on her computer, where she manipulates it with filters and effects. When the image is the way she wants it, she prints out a full-color image from her inkjet printer and carefully traces each color onto multiple lino blocks for cutting. You can also use the computer to create color separations and to view color combinations before you print, although you will notice a difference between the transmissive color on your monitor and the reflective color on your paper.

If your blocks are misaligned, thin lines of misregistered color will appear in the final print. To prevent these unsightly lines from appearing, the artist must "trap" the problem before it occurs. Trapping is a method of registering the image to trap the next color (see illustration below). There are two types of trapping: chokes and swells. In a choke, the image on one block is printed slightly larger than the one on the next block to choke the image inside it. In a swell, the image on one block is made larger to block out the image on the previous block.

I like to watercolor over my black proof prints to determine which colors will work best with my image. It's great fun experimenting with roller blends as well as overprinting with transparent color and finishing varnishes. Roller blends are made by putting two colors onto one roller. A bead of each color is placed side by side on the ink slab, blended in the middle with the roller and then rolled onto the surface of the block for a three-color effect. Because the colors will eventually blend into one color on the roller, the print runs are shorter for roller blends.

I highly recommend that every artist experiment with the possibilities of color.

Designed out — Dots print on a solid background. Therefore no trapping is required.

Choke — The background is printed so that it bleeds into the black dot.

Swell — The black dot is printed larger than the background.

Misregistration – The background and dot do not line up, revealing the white paper.

PRINTING WITH A PRESS

Many artists print their blocks on letterpress printing machines. Primarily designed for printing movable lead type, these presses are now used to print wood engravings and relief blocks, as well as type, for fine press books and artists' books.

The primary advantages to printing on a press are ease of registration, control of inking, control of pressure, versatility in the use of papers, speed of taking impressions and flexibility of printing materials (for example, being able to print hand-set lead type and dingbats, borders and Linotype slugs). The many adjustments and controls on a printing press can improve print quality and expand the effects that can be achieved — both very attractive features for many artists.

Printmakers use two kinds of presses for printing blocks: the flat bed cylinder press and the platen press.

Cylinder Presses

Simple cylinder presses, such as the etching presses used to print intaglio plates, are excellent for printing plastics, unmounted lino and thin plywood woodcuts and, with a little more setup, thicker

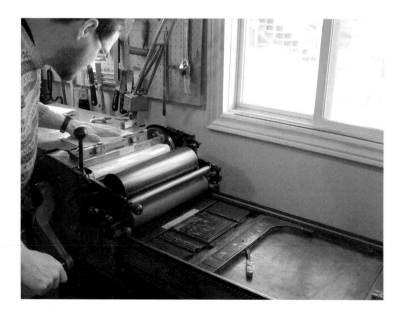

wood blocks. The letterpress flat bed cylinder press has a flat bed, where the block rests, and a cylinder that passes over the block, pressing the paper and block together.

The advantage of the cylinder press is that it exerts an even pressure over the small area where the cylinder and block are in contact. Greater pressure can be maintained over this small area than can be achieved with a platen press. The disadvantage of this press is that the paper can stretch when printed because of the movement and pressure exerted by the cylinder. This can be a problem when you are doing multiple block printing.

I use a Vandercook SP15 proof press from the 1960s with a printing bed that is 15 x 31.5 inches. The SP stands for Simple Precision and it was used as a test press for printing movable type and halftone blocks. The Vandercook proof presses come in other sizes, too, from the Universal models that can print an 18 x 24 inch sheet to the early rocker type presses (so-called because the cylinder moves over the printing form in a rocking motion) that can print a 6 x 11 inch sheet. It's a very sophisticated machine. The electric inking system keeps the ink rolled out evenly while printing. The inking roller height is adjustable, providing better control over the inking of the surface; for example, when set for type-high printing, the rollers will not ink shallow areas of the block. The built-in registration system on the press consists of an adjustable side guide and grippers that hold the paper to the cylinder while printing. Because of the many fine adjustments on these two features, I can twist and shift the paper to meet any registration problem. (You can find out all about the Vandercook and its history, uses and various models from Mark Wilden's web site at http://vandercookpress.info/ .)

Platen Presses
There are three major types of platen presses: the Albion-style flat bed, the clamshell and the screw type press. The flat bed platens have two horizontal metal plate beds that squeeze the block and paper between them. The clamshell platen has two vertical plate beds, one of which

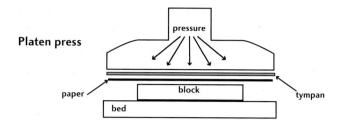

Platen press

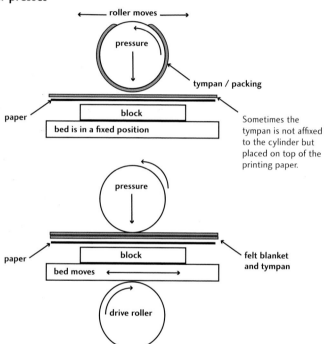

Cylinder presses

is hinged to close against the other (not unlike an upright clamshell). Clamshell presses require skill and knowledge of their parts and functions to operate them properly. The block must be securely locked into the press vertically for printing. If it is at all loose, it can fall out and be completely crushed in the press. Small screw type bookbinding presses are good for printing small blocks and are not as heavy as their larger cousins, making them good choices for the small studio.

You can make a platen press for printing your blocks. You need

two flat pieces of 1-inch steel with 1-inch holes drilled in the corners and one piece of $^1/_2$-inch steel plate with the corners cut off. These are your platens. Bolt the first two platens together with a 1-inch threaded steel bar. The threaded bar should be about 2 feet long. You'll need 16 bolts. Once you've built this cube, the third steel platen bed is placed between the other two platens with a hydraulic car jack beneath it to hold it in place. Plywood blocks are the blocks of choice for this press, because they are easy to slip in and out of the press.

Homemade platen press

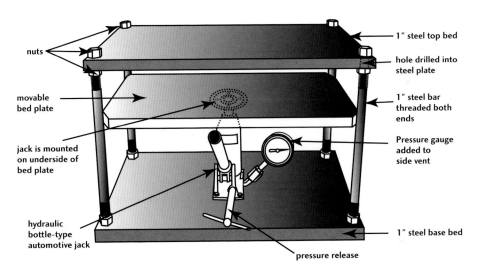

nuts

movable
bed plate

jack is mounted
on underside of
bed plate

hydraulic
bottle-type
automotive jack

1" steel top bed

hole drilled into
steel plate

1" steel bar
threaded both
ends

Pressure gauge
added to
side vent

1" steel base bed

pressure release

Using the Letterpress

Many platen and cylinder presses are designed to be used for the printing of lead and wood type. These presses are collectively known as letterpresses. To use a letterpress printing press, the block must be the proper height. All the letterpress machines print type-high blocks and lead type. Type high is 0.918 inch or about $^{15}/_{16}$ inch thick (see illustration page 125). If you try to print a block that is thicker or thinner than this, you can expect problems.

The pressure on the block is adjusted by adding tympan paper (aka packing). The tympan paper is placed between the sheet to be

printed and the pressure-exerting impression cylinder or platen. It should be made of a hard card stock or layers of a strong oiled paper rather than a soft or spongy paper. The only exception to this rule is when the block you are trying to print is warped. In this case, using a soft etcher's felt blanket between the printing paper and the press will allow the paper to conform to the shape of the block.

The process of adjusting the printing pressure over specific areas of the block or leveling the block on the press is called "make-ready" by letterpress printers. There are two types of make-ready: overlays and underlays. Overlays are pieces of paper or tape attached to the tympan (sometimes between tympan sheets) above the block and behind the sheet being printed. They are used to adjust the amount of pressure exerted on those areas of the block that are not printing or that are printing lightly because the block dips slightly there. Underlays are used to level the block so that it prints evenly. A block that is slightly wedge shaped may need to have an underlay of masking tape placed under one side to level it. A block that rocks on the press because of a low corner may need to have a small piece of paper placed under the offending corner.

You can buy presses with a variety of bed sizes to suit your needs and space requirements. Many of the larger platen presses and cylinder presses are too heavy and expensive for the casual artist, but fortunately you can still find secondhand tabletop hobby presses that are ideal for printing small images. Most of these presses can be purchased from Don Black Linecasting (see Resources), old print shops or at online auctions. Alternatively, printmaking cooperatives and art schools have presses that can be rented or used in conjunction with courses of study. I also know artists who use old screw type tabletop book binding presses with great success.

Learning to use the printing press requires time and patience. The best way to begin this particular journey is to consult books on the subject. John Ryder's *Printing for Pleasure* and old letterpress textbooks such as Frank S. Henry's *Printing for School and Shop* contain a wealth of information for the beginner.

Printing packing

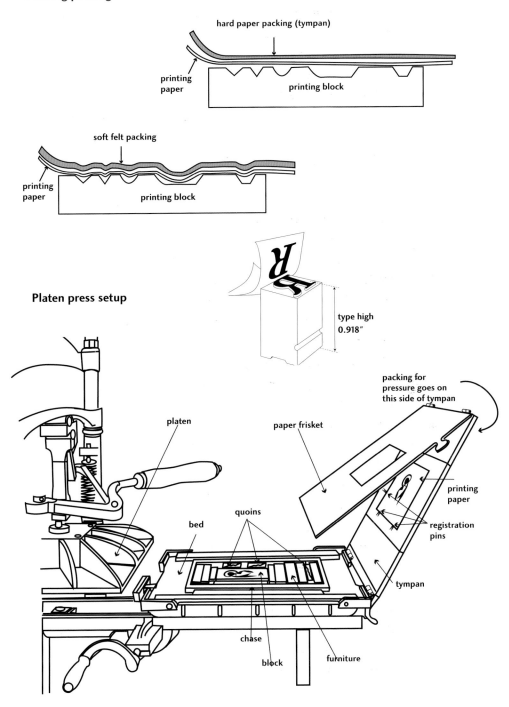

hard paper packing (tympan)

printing paper

printing block

soft felt packing

printing paper

printing block

Platen press setup

type high
0.918"

packing for pressure goes on this side of tympan

paper frisket

platen

printing paper

registration pins

quoins

bed

tympan

chase

block

furniture

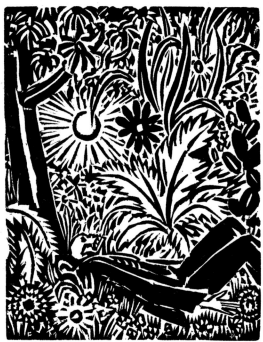

Frans Masereel's *woodcuts and graphic novels were banned in Germany during World War II but widely distributed in other countries. Masereel rejected the label of political artist and held no political affiliation, condemning all forms of political oppression, war, injustice and the misuse of power and money. Because his woodcut novels had no words they could be read in any country. His woodcuts had a painterly quality that made them appear more like ink drawings than woodcuts.*

top: *Mein Stunden Buch - 165 Holzschnitte.* 1926. Book; 4.75" x 6.125"

bottom: Wood engraving from the book; 3.5" x 2.75"

THE EDITION

FTER YOU'VE PRINTED your block on good paper, it is a traditional part of the process to sign and number the prints. This indicates to the collector of your work how many copies you made of the image and that you do not intend to print the block again. After the edition is completed, the block is usually cancelled by striking lines through the image on the block, making further duplicate impressions impossible. Sometimes this cancelled block is printed as further proof that the block is indeed cancelled.

Some engravers believe that they should be able to print their blocks in unlimited editions. They argue that wood engraving blocks experience little wear and can be printed in huge editions without loss of detail in the image. If you intend to print your blocks in unlimited editions, the prints can be signed but the edition number should be left off.

Limited editions are usually signed in pencil in the bottom margin of each print. The edition number is expressed as a fraction; for example, 10/30 means that it is the 10th print of 30 prints made. The edition number is usually found in the left bottom margin below the printed image. The title of the work is added in the middle of the margin followed by its creation date, and the signature is usually found in the lower right-hand corner.

Printmakers document their prints in various ways. It is important to keep a record of what you've done so that your collectors know what they own. Other terms or marks that you may encounter include:

- *Trial Proof* These prints usually have the artist's handwritten notes and sometimes drawings on them regarding proposed

changes to the print. They often are labeled with the words: first state, second state, etc.

◆ *Bon à tirer or Printer's Proof* Bon à tirer means "good to pull" and indicates that the print is the standard of the edition. All other prints in the edition were compared to it for quality and consistency.

◆ *Artist's Proof* A print with A/P in the corner where you would expect to find the edition number is a print pulled by the artist and retained outside the regular edition.

◆ *Cancellation Proof* This is the impression that is made to prove that the block has been destroyed.

HANDLING AND STORAGE

Paper is fragile and can be damaged by exposure to heat, light, moisture and dust. Poor handling and storage of your prints can result in creases and tears that are difficult to repair.

A century or two ago prints were rarely framed. They were stored in a box and brought out for viewing. If you are storing prints flat on top of each other, the prints should be interleaved with acid-free tissue paper. This protects the printed surface of each print from scuffs and from the migration of oils from the other prints in the stack. Prints should be stored in a closed light-safe box away from moisture and temperature extremes. Museums often mat their prints and store them in dust-resistant Solander boxes which can be purchased from library service suppliers and photographic supply stores.

Large prints should be interleaved with sheets of acid-free tissue paper and rolled if they can't be stored flat. The roll of prints can be placed in a cardboard tube for storage.

Blocks should be cleaned before they are stored. Although I prefer to print off the remaining ink on my blocks onto newsprint, then wipe them with a cloth to remove any excess, other printmakers use mineral spirits to clean their blocks. Whatever method you choose, use a soft cloth and try not to rub any excess ink into the details of the

block. If you are using water-based inks, limit the amount of water you use to clean the block to prevent damaging the surface.

Wood engraving blocks can last for years if they are stored properly upright in a cool, dry place that allows air to circulate around them. This will prevent the blocks from cracking prematurely.

If you are using oil-based inks on Resingrave, the block can be cleaned with mineral spirits. Avoid any solvent containing methylene chloride, which can melt the epoxy.

WHAT TO DO WITH YOUR PRINTS

You've worked hard and created a stack of woodcuts, wood engravings or linocuts. Now what do you do with them? In the 19th century, exported tea from Japan was wrapped in handprinted wood block prints by master artists. The strong two-dimensional images of these Japanese woodcuts had an important influence on Impressionist and post-Impressionist artists of the time. Although you may not want to use your images as wrapping paper, artists have come up with many different and often surprising ways to put their prints to work.

Framing Prints

Paper expands and contracts as it takes on moisture from the air. If you mount a print by fastening all four corners to the mat, the print will eventually wrinkle and warp in the frame. Instead, hinge the print from the top with acid-free tape. This allows the print to breathe. The tape should be affixed to the back of the print in the corners. For larger prints you can put an additional piece of tape in the top center.

Traditionally, prints are matted up to the printed image. To prolong the life of your prints, choose acid-free mat board whenever possible. Acid seeps from cheap mat board into the print and can stain, discolor and deteriorate the paper over time. Your work can also be displayed in a shadow box frame to show all of the sheet's beauty, from deckle edges to paper texture.

Adam Thyssen *engraves on maple. He prefers to print on BFK Rives paper and is particularly fond of the multiple-line tool for shading. He says this about drawing on the block; "I like the immediacy of sitting down with a general idea, a pencil, eraser and just going to town – drawing and editing for however long it takes directly on the block – and starting to cut immediately after the drawing is finished."*

second hand stories. 2004. Wood engraving and letterpress printed on card; 5.25" x 11"

Leah Springate *handprinted this deck of cards from 55 original lino blocks. The cards were printed on a Vandercook proof press and a clamshell platen press. They were impressed onto 3-ply artist bristol board. After printing the cards she sprayed an aerosol varnish over the cards to give them a durable matte finish. She then made boxes for holding the decks.*

Playing Cards. 1991. Linoleum printed on 3-ply bristol board; 2.25" x 3.5"

George Walker. *The handmade book is a natural place to find woodcuts and wood engravings. Pictured here is Edgar Allan Poe's* The Raven, *handprinted with eight original wood engravings impressed onto handmade paper and limited to an edition of 65 copies. Each copy is signed, numbered and hand bound. I printed this book on my Vandercook SP15 press from maple wood engraving blocks and lead type.*

The Raven. 2005. 24-page hand-sewn book; 9.75" x 6.5"

Making Artist's Books

Why do we persist in caging prints in frames so that we can only imagine what the paper feels like? The texture of the paper and the rich ink laid carefully on the page begs to be touched. This is precisely why the artist's book is such a wonderful vehicle for the hand-printed woodcut. It brings the print back into our hands, allowing us to feel the printed page and to smell the ink. Personally, I can't keep my hands off them!

I've used handmade papers and letterpress typography to create books for many years. It all started when I saw an exhibition of early printed books at a museum. Block books, which first appeared in the late 15th century, have the text and images cut onto the same block. The sequence-based illustrations of the early block books — for example, the famous *Biblia pauperum* (the Bible of the poor) — have a graphic novel feel to them. I remember thinking, "Wow! These are like woodcut comic books!" And once I discovered the work of Frans Masereel and Lynd Ward, I was hooked.

Storytelling in pictures is an old craft but it still works today. From the block book to the contemporary graphic novel, pictures without words are a universal language with exciting possibilities.

Other styles in the book format that the woodcut artist can explore include pop-ups, accordion-folded books and diptych panels. To see how you can make your block prints come alive in the book format, pick up a book on bookbinding techniques such as Keith Smith's *Non-adhesive Bookbinding* or Frans Zeir's *Books, Boxes and Portfolios*. Courses on bookbinding can be found by contacting the Canadian Bookbinders and Book Artists Guild (www.cbbag.ca), The Center for Book Arts (USA) (www.centerforbookarts.org), The Book Arts Web (USA) (www.philobiblon.com) and Designer Bookbinders (UK) (www.designerbookbinders.org.uk).

Experimenting

When we lose our sense of play, we lose an irreplaceable part of ourselves. Children are always the best experimenters, because they don't carry around any baggage that prevents them from trying something new. The young people I taught at the Art Gallery of Ontario always impressed me with the new ways they could find for using their linocuts and woodcuts. Similarly, when Bill Poole, a mentor of mine from the Ontario College of Art, asked his printmaking class to make a 3-D object with their woodcuts, students created everything from woodcut-printed mobiles to cutout dolls.

Try using scratchboard, an inexpensive material used to give the effect of a relief print. It is essentially a board coated with black ink. You scratch through the ink, revealing the white board underneath. Many wood engravers use this material to experiment with new techniques and practice their white-line skills.

If your interest in woodcut is decorative, you can try making wall paper, gift wrapping, lampshades, hats, clock faces, paper for collage, woodcut-collaged papier-mâché, playing cards and umbrellas. Woodcuts also work well with the decoupage technique of pasting and varnishing cutouts onto frames, table trays and furniture.

With the ever-increasing popularity of body art, some artists are using woodcuts to print designs and symbols on their bodies for performance art exhibitions. Woodcuts and linocuts are also appearing in gallery installations, where the transparency of the paper and the shadows created by the images are combined with spotlights, music and fans to create breathtaking spectacles.

I always seem to find something new to explore when making images on wood. It's impossible to exhaust all the variables of texture, tone, pattern and color. You may have a cause to champion or a story to illustrate or even just a feeling that needs to be expressed. I hope this book has sparked your interest and will inspire you to pick up a gouge or graver and make your mark.

Color Printing Using a Reduction Block

A reduction block is a print made by gradually reducing the printing area by cutting it away between colors. Below is an example of a three-color reduction print.

First print the block without cutting a single line. In this case I'm using yellow, but you can use any color that works for your image (light colors are usually best to start with).

Next draw your image on the block you have just printed. Then cut out all the areas that you want to be yellow. When you are done, print your next color. In this case I've chosen red.

After you've printed your red (it may look orange because of the yellow), cut away everything that you want to appear in red. Now you're ready to print your final color. Here I've used black.

Here is all I have left of my original block. I can't print the red or yellow again because I've changed the block.

Color Printing Using Multiple Blocks

Printing with multiple blocks requires that you use a registration system so that all the blocks print in the correct position. Using blocks of the same size can help make registering them easier.

1. Yellow

2. light orange

3. Red

4. Black (key block)

Above are the four blocks that I used to make the full-color image (B) below . The first block I cut was the key block. I transferred the key block image to the other blocks and then changed the design by drawing over my key image before cutting the remaining blocks.They are shown above in the order I printed them: yellow, light orange, red and black (key block).

A

B

On the left (A) is the print after the first three colors have been printed. On the right (B) is the completed print with the key block printed in black over the colors. There is no limit to the number of blocks or colors an artist can use to make a print. Cut all the blocks and then make proofs, experimenting with different color combinations.

Lisa Neighbour *has used a roller blend in the background of these linocuts. The ink roller is rolled up with a color on either end of the roller. After the color is blended on the ink slab it is rolled onto the block. Lisa used a multiple-block method for these prints, first printing the blend, and then cutting each image out of linoleum and printing these blocks over the blend.*

Masks (Green — Diablo) (Blue — Bruha). 1995. Linocut; 8″ x 12″

Elizabeth Forrest *uses the Japanese technique of printing to create her images. To achieve color richness, a single print may contain more than 30 printings of transparent watercolor pigments. This work, part of an ongoing series, explores the multiple layering of color pigments using a minimalist grid. She is interested in both acknowledging and contradicting the structure of the grid, using a range of color values with a painterly approach.*

Courtyard II. 2003. Water-based (Japanese) woodcut on Uchiyama washi; 21.5″ x 22″

Nigel Nolan *works on large pieces of white plastic known as lumaboard. He likes this material because it is easy to cut; moving the large sheets around is not as difficult as it would be if they were made from wood or linoleum. He uses oil-based inks and prints them on a massive press powered by an industrial hydraulic jack.*

Sales Help Landscape V. 2003.

Lumaboard reduction relief cut; 24" x 36"

Chet Phillips *succumbed to the computer revolution and abandoned his woodcut tools but not his love of woodcut. Over the last ten years he has worked digitally, using Corel's Painter to create the illusion of the woodcut on the computer. This is not a woodcut or a linocut, but it sure looks like one.*
I Love Sushi. 2003. Digital woodcut; size is mutable

Lisa Levitt *takes her prints to the next dimension, 3-D! "The Clothes Series" is a series of linoleum prints impressed on* washi *paper and then manipulated so that the paper no longer hangs flat but takes on the appearance of hanging clothes. By overprinting with subtle transparent tints, Lisa makes the paper appear more like cloth. She prints with oil-based inks on an etching press.*
Undershirt 3. 2000. Linocut printed on kozo; 15″ x 21″

Olga Philip *makes her own paper and is best known for nuanced and layered imagery dealing with portraiture, family, relationships, passage of time, mortality and the fragmentations of modern life. She uses oil-based inks and prints her basswood blocks on a press.*

Cover woodcut for OCAP #20 Printmaking Anthology of the Ontario College of Art. 1998. Woodcut; 11" x 7.5"

Sharon Merkur *printed this image on washi paper after cutting her plywood blocks apart like a jigsaw puzzle. She layered ink glazes (sometimes hundreds) onto the paper, creating a luminous depth to her prints. She mixed her inks by combining oil paint with transparent-base printer's ink.*

Evening Shadow. 1985. Woodcut on plywood; 18" x 24"

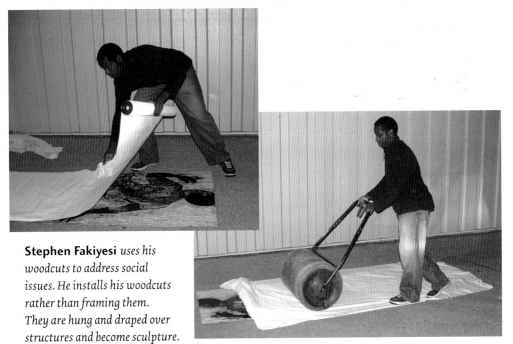

Stephen Fakiyesi *uses his woodcuts to address social issues. He installs his woodcuts rather than framing them. They are hung and draped over structures and become sculpture. He prints his large blocks with a lawn roller. Fakiyesi says of his work, "In my woodblock print installations I address issues of social injustice, systemic racism and violence drawn from historical and contemporary events as well as personal experiences. My artwork veritably parallels my involvement in the Black community, the Christian community and the art community."*

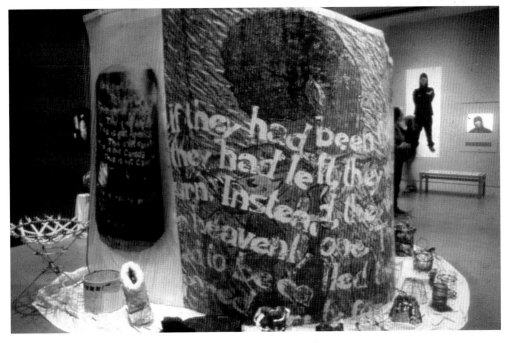

Neither Here nor There. Art Gallery of Ontario Art Starts Neighbourhood Cultural Centre, Oh Canada Project, 2004.
Woodcut; 10' x 26'

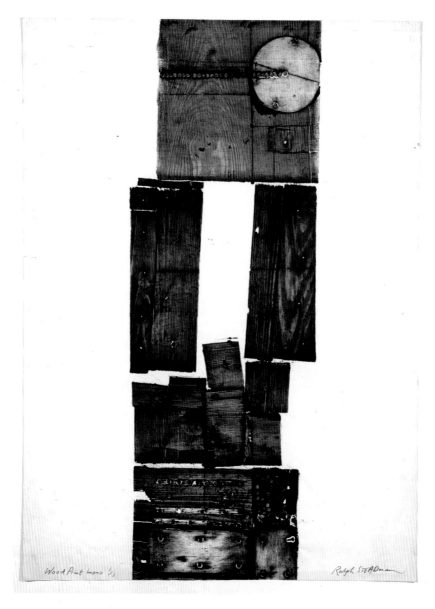

Ralph Steadman *has always been a printmaker at heart. When asked about woodcuts he had a lot of insight. "Why do you need to carve into the wood when the grain may have something to say for itself? My experiment: putting wood pieces through an old etching press captures the very essence of the wood, the nails and the score marks, producing an exact 'map' of the surfaces themselves." Steadman's woodcuts are an example of woodcut prints cut by nature to show what nature has to say. Brilliant!*
Wood Print. 1966. Woodcut printed intaglio and relief; 18″ x 24″

Naoko Matsubara *has been associated with master artists of the Japanese wood block such as Munkata Shikō and masters of the Western style such as Fritz Eichenberg, among many other influential and important contemporary artists. Matsubara epitomizes the convergence of Western and Japanese printmaking techniques. Her woodcuts are made on the plank using bass plywood, solid mahogany, solid pine, solid cedar or beech plywood. Her papers of choice are washi from the fibers of kozo, mitsumata and gampi. She prints her images on a printing press using oil-based inks.*

right: *Solitude,* 1971. woodcut; 11" x 14"
below: *A Rider,* 2000. woodcut; 8.5" x 14"

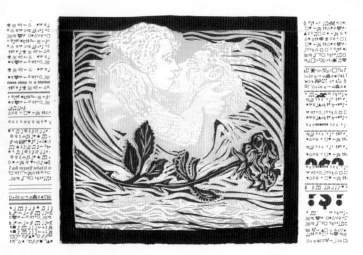

George Walker. *This color print was made by combining two linocuts, two wood engravings and lead type. The blocks were printed on handmade paper on a Vandercook SP15 proof press which makes registering multiple blocks and adjusting the ink and impression fast and efficient. All the colors were custom mixed specifically for this print.*
Language System for Lovers. 1994. Wood engraving, linocut and letterpress; 11" x 15"

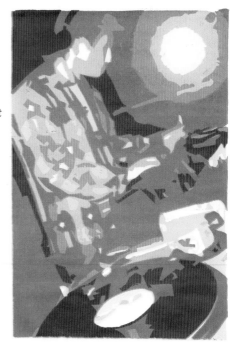

Holly Greenberg's *linocut demonstrates how new technologies can influence the creative process. She takes a digital photograph of her subject and manipulates it on the computer. She then prints out the result on her ink jet printer and copies the image by hand onto a single linoleum block. The block is then repeatedly carved and printed — up to nine times — onto hosho paper, employing water-based inks on an etching press.*
Eternal Spin. 2004. Seven-color reductive linoleum cut; 9" x 13"

Frederica Tomas *works primarily on linoleum using a Speedball lino-cutting tool, a 1.5 mm V gouge and a 2 mm U gouge. Her linocuts of saints, sinners, strange beasts and pop culture are proofed by hand with her thumbnail! When it comes to printing good copies she prints on a Vandercook proof press. She adds color to her prints by painting over the oil-based black ink with watercolor paints.*

Salomé. 2003. Linoleum printed on gampi; 5.5" x 9.25"

Peter Barron *chooses water-based inks for printing, layering the colored blocks first and then finishing by overprinting the key (black) block. He cuts his blocks with both parting tools and U gouges. His bold blacks and bright colors create work that jumps off the page.*

May I introduce. 2002. Woodcut, mixed media; 11.9" x 13.3"

Suezan Aikins *and* **Sam Rogers** *work in a partnership to create their luminous and detailed prints using the Japanese style of printing. Suezan says, "The technique we use involves water-based pigments pressed deeply into barely sized paper made of extraordinarily long and translucent kozo fibers, which allows us to register 40 odd layers of uniquely luminous colors." Their work blends the luminous qualities of the ukiyo-e style with a contemporary sensibility about Western themes and thought.*

Sam Rogers (above), *For Sail.* 1999. Woodcut; 25.625" x 10.875"

Suezan Aikins (right), *Autumn Moon.* 1992. Woodcut; 9.25" x 21"

A STEP-BY-STEP GUIDE TO MAKING A WOOD ENGRAVING

The following pages offer a step-by-step guide to creating a wood engraving. The type of wood and tools differ with wood engraving, but the steps are similar to those used in relief printing for woodcut. Often it is easier to learn a process if you follow a pictorial sequence. Once you have the block prepared (page 37), there are three basic stages to making a wood engraving:

A. Make a drawing and transfer it to your block.
(Remember, it will print backwards.)

B. Engrave your image by cutting away all the areas you don't want to print.

C. Print your image: ink your block and impress it onto a piece of paper.

STAGE A

MAKING A DRAWING

Many artists draw directly on the block using a soft 3B pencil. Others begin their work on paper and then transfer the image to the block with carbon paper. Whatever method you pick, remember one thing: the drawing must appear as its mirror image on the block. Take care not to press too hard with the pencil, because too much pressure can cause indentations in the block which may show in the final print.

1 **Make a sketch.** Draw a sketch of how you want the image to print. Use a soft 3B pencil. Use a paper that you can see through, such as tracing paper.

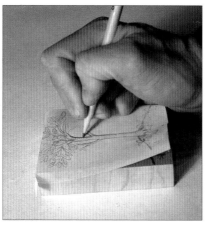

2 **Transfer the drawing.** Use the end grain of seasoned sugar maple (*Acer saccharum*, page 31) for your block. Flip the paper over and tape it to the block. Trace your lines through the paper to transfer the soft pencil. Make sure the surface of the block is as smooth and flat as possible — otherwise, the imperfections may print (see page 41).

3 **Check the transfer.** If you've taped the paper securely to the block, you should be able to lift the paper to check your progress. You can also rub the back of the transfer sheet with a soft pencil (3B) so that you have more graphite to transfer.

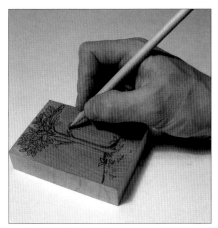

4 **Strengthen the transfer.** Make adjustments and fix areas that didn't transfer with the initial pencil work. I will often make notes to myself on the block, using pencil. I won't ink these notes, but they will remind me about a technique I may want to use.

5 **Draw over the pencil.** Use a black waterproof drawing ink or a waterproof black marker. Drawing over the pencil prevents the pencil from smudging during the engraving process.

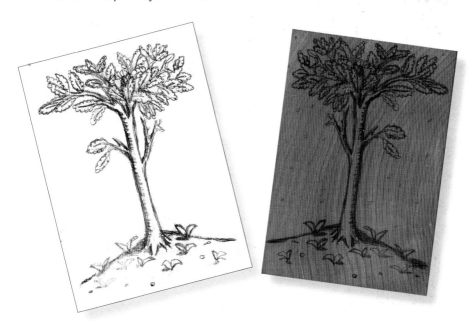

Tip

Transfer a photocopy

You can transfer a photocopy directly onto your block by rubbing the block surface with a small amount of Estisol or wintergreen oil and running the block through a press (page 72). Be sure to secure your photocopy to the block or the paper may shift during the transfer.

ENGRAVING THE BLOCK

If you find that your hand shakes while you are cutting, it is probably because your arm is not supported properly. To steady your hand, support your wrist or forearm with a stack of books or a cushion. The block rests on an engraver's pad or sandbag. When you engrave curved lines, turn the block on the sandbag, and keep your tool hand relatively stationary. It's best to have the block at chest height so that you can keep your back as straight as possible while working. Take your time; there's no need to rush.

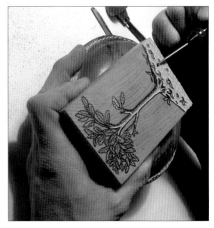

6 **Engraving with a power cutter.** It's faster to rough out the large open areas with a rotary power carver and a $3/32$-inch-diameter ball-tipped bur.

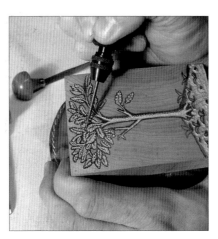

7 **Use a smaller bur for the leaves.** Change the bur to a $1/32$-inch-diameter ball-tipped bur for making the details in the mid ribs of the leaves.

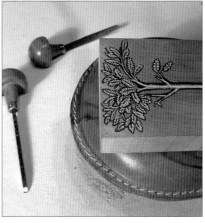

8 **Using hand tools.** Now you can begin the detailed engraving with the burin and the spitsticker hand tools. See pages 49–53 for selecting the right engraving tools.

Tip

Gently scratch your first lines into the surface

Use an awl or a metal scribe to create a channel that your tools can follow with more control later. You can then go back into the original lines and make them deeper, wider or more tapered. Never try to cut a long line in one sweeping motion; instead, stitch the line by making a series of short lines.

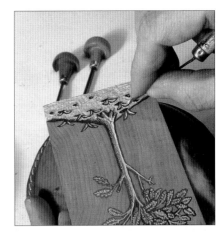

⑨ Using hand tools. Hold the engraving tool in your palm, gripping the shank with your thumb and forefinger. Many engravers prefer hand tools over the power cutter because they offer more control.

⑩ Using hand tools. Holding the block firmly use the burin to engrave details in the foliage. See pages 80–81 for more information on how to engrave with the burin and spitsticker.

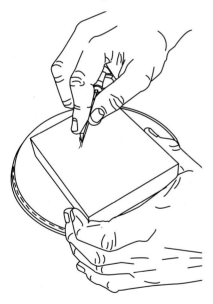

⑪ Hand tools. For the background, I'm using a sharply pointed metal scribe to create a white-dot pattern in the background.

Tip

Grip the block firmly!

Keep your fingers out of the path of the tool! Your fingers should be positioned just below the top edge of the block, with your thumb, forefinger and middle finger gripping the sides, as pictured above.

STAGE

PRINTING THE BLOCK

Preparation is the key to successful printing. Clear a space with enough room for all of your materials and tools. Cut your paper all to the same size. Prepare a place for the wet prints to dry. Set up your paper registration (pages 115–117). Set up your ink slab and prepare your ink. Your work area should look like the illustration below, under Step 13. Make sure you have given yourself enough time to print and to clean up aftward. A rush job will often look like a rush job, so approach the task with patience and thoughtfulness.

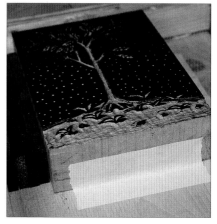

(12) **Preparation.** Secure your block to a jig for printing, using tape and spacers. I use a simple bench hook (page 113) that also serves as a registration device for my paper.

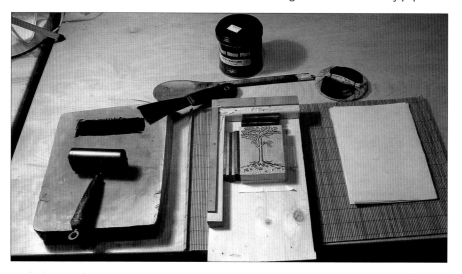

(13) **The printing space.** A well-organized printing space will make the printing job a pleasure. A cluttered workspace can be a disaster for finding tools and controlling ink. Be sure to cut extra paper for proofing, leaving the good paper for the best impressions.

Tip

Rub a bit of talc on your hands.

When you work with ink it is easy to get an annoying speck on your hands that can quickly spread to your paper and everything else. You could wash your hands but the faster solution is to rub some baby powder on your hands. It will absorb the ink and get you ready to work again more quickly.

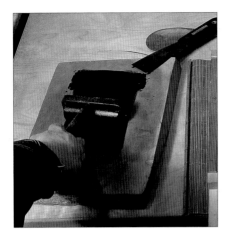

STEP

(14) **Roll out the ink.** Use a lean, tacky, oil-based printing ink and roll it out evenly on a sheet of plate glass or an old piece of marble slab. Be careful not to use too much ink or you will fill in the fine details.

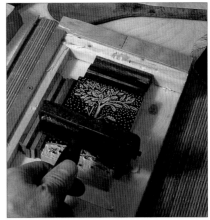

STEP

(15) **Ink your block.** Roll an even pass of ink onto the surface of the block. Don't stop during the pass or you'll leave a line that may show up in your print. It may take several passes to ink the surface fully.

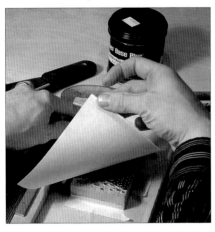

STEP

(16) **Place your paper onto the block.** Make sure your hands are clean. Use your registration marks to ensure proper positioning. Line up the paper with the marks and let it gently fall over the block surface. Gently rub the paper so it adheres to the block. Allow the natural tack of the ink to hold the paper in place.

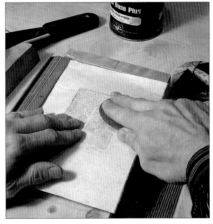

STEP

(17) **Printing.** Burnish the back of the paper to transfer the image from the block. Use a wooden spoon, steel spoon or Japanese baren to rub the paper. Use a circular motion. Some paper may begin to pill, and you will need to place another sheet between your printing paper and burnishing tool. You can check your progress by lifting a corner to take a peek.

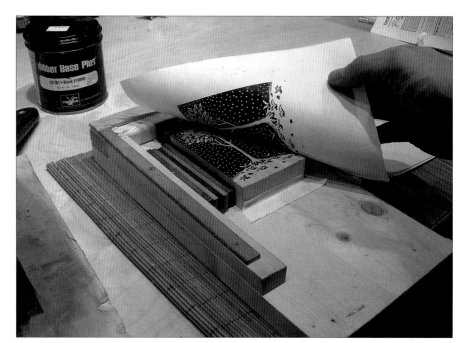

(18) **The grand finale.** Lift the paper by the corners in one swift motion. Dry the print

STEP

in the open air for at least 12 hours (see pages 114–115). Printed sheets can be stacked between newsprint as you are printing. Do not stack them directly on top of each other as the wet ink may transfer to the back of the other prints. Always check your fingers to make sure they are clean before lifting the paper off the block.

WHAT WAS USED TO MAKE THIS PRINT?

Materials & Tools

Materials:

End-grain maple block, 2³/₄″ x 4″ x ¹⁵/₁₆″
Washi paper
Vegetable oil or coconut-based esters as
 solvent replacement, or mineral spirits
 (to clean up the ink)
Oil-based printing ink

Tools:

Ink brayer
Wooden or steel spoon, or Japanese baren
Rotary power engraver with ³/₃₂″ and ¹/₃₂″
 diameter ball-tipped burs
Burin
Spitsticker
Awl or scribe
Engraver's pad (leather pillow filled with sand)
Bench hook or similar jig to hold block and
 register paper
3B pencil and fine-point black marker

A STEP-BY-STEP GUIDE TO MAKING A LINOCUT

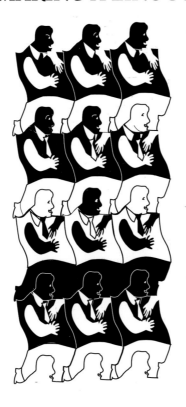

Here is how to make a tessellated linocut. A tessellation is a mosaic image that fits together like a puzzle. The artist M.C. Escher (1898–1972) made the technique famous with his prints, but the technique in mathematics dates back to the 17th century. This is a good exercise to explore pattern and positive and negative space. As in the previous exercise, there are three stages:

A. Make a drawing and transfer it to your block. (Remember, it will print backwards.)

B. Carve your image by cutting away all the areas you don't want to print.

C. Print your image: ink your block and impress it onto a piece of paper.

STAGE A

MAKING A DRAWING

To make a tessellation you start with a basic shape such as a square, rectangle or triangle. You can draw anything you like, but the advantage of a tessellated image is that you can tile it to make a larger print. Because the image fits together like a jigsaw puzzle, this technique is great for creating patterns to print on cloth for installations or art-wear clothing. For the tessellation I've made here, I've grouped the little men together to make a larger linocut so that I can vary the individual characters.

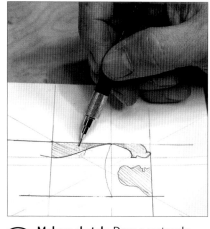

1 Make a sketch. Draw a rectangle, using a ruler. Within the rectangle, draw your design on two of the four sides, as pictured above. I've drawn a little man, using the space between his legs to create the head.

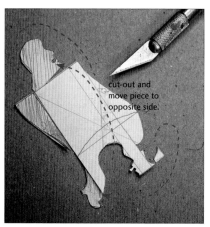

cut-out and move piece to opposite side.

2 Cut out your template. With an X-acto knife, cut out parts of your design (here the head and back/foot) and move them to the opposite side. You may tape these cutouts in place. This final shape will be your template, which you can trace to make the tiled design.

3 Trace your tessellation. On a larger piece of paper, create a grid in pencil that you can tile your design onto. Use your template to trace the shape repeatedly, into an interlocking pattern. Each shape you trace from the template should fit exactly into its neighbor both above and below, like pieces in a jigsaw puzzle.

Tip

Transfer your drawing

You can skip the transfer completely by drawing your image directly onto the linoleum plate. See pages 71–73 for more on transferring methods.

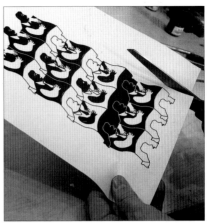

(4) **Ink your image.** After you have penciled in all the lines, it's time to ink in your image (with drawing ink) so that you can photocopy it. Make several dark photocopies of your final image (in case one doesn't work out).

(5) **Close crop the photocopy.** Cut around your photocopied image so that it fits nicely within the margins of your linoleum plate.

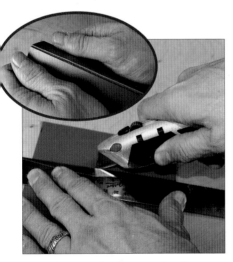

(6) **Cut your linoleum to size**. If your linoleum plate is too large you can cut it down by scoring the face side and bending it backwards. Use a mat knife to cut through the burlap backing. You want your photocopy to fit within the boundaries of the plate.

(7) **Transfer your photocopy.** Toner is fused onto paper with heat, so it stands to reason that you can use a household iron (set to high) to transfer your photocopy to a lino plate. Rub the back of the photocopy with the iron, using firm pressure. Use a fresh photocopy for best results. A few drops of oil of wintergreen rubbed onto the lino will also help.

STAGE B

CUTTING THE BLOCK

Linoleum, also known as battleship linoleum, or lino for short, is a flooring material. If your lino is difficult to cut, you may want to warm it up first. You can use a hot plate or a hair dryer to gently warm the material before cutting into it. See page 29 for more details about linoleum for printmaking. A new, softer material made of rubber is often sold in art supply stores as a replacement for lino. Rubber doesn't need to be heated! You can use your woodcut tools to cut lino. See pages 42–48 for more information about tools.

(8) **Ink in your** art after you have transferred it to the linoleum. Most transfers need to be inked with drawing ink to redefine light areas or areas that did not transfer.

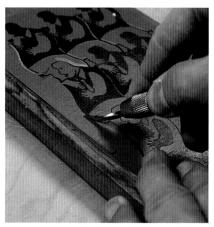

(9) **Using a Speedball** lino cutter, start to outline your image by cutting with the smallest parting tool or gouge. Cut on either side of your black lines.

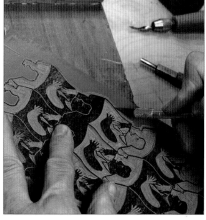

(10) **Outline the outside** shape of your image with a parting tool and then cut through the lino with an X-acto knife.

Tip

Cut carefully with sharp tools

Always cut your lino using a bench hook (page 48). Remember to keep your hand (especially your fingers) out of the path you are cutting toward. Most accidents happen with dull tools. Use new cutting nibs if you are using a Speedball cutter. Sharp tools are safer! See page 55 for details.

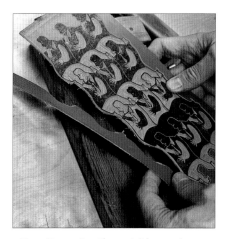

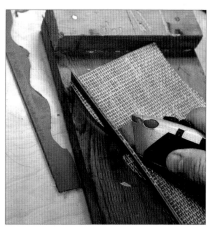

(11) **Removing the outside** margins leaves you with a shape that is easy to register and eliminates misprinting in the areas you want to remain clean.

(12) **After gently breaking** the lino along your incised lines, release the burlap backing with a mat knife. The top surface breaks easily, but sometimes the backing can be finicky!

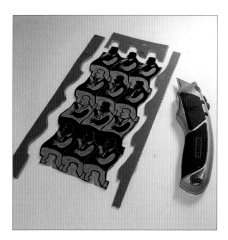

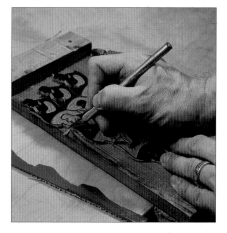

(13) **A puzzle-shaped lino** block should be the result of your effort. There will be pieces left over that you can use as bearing strips, so don't throw them out.

(14) **Clean the edges** with a sharp knife, removing any stray pieces of burlap or material that protrude above the surface and that may interfere with the inking and printing.

Tip

Take your time!

If you slip and cut a piece of lino that you didn't intend to remove, you can glue it back with PVA glue — but it will need time to dry. It is better to take your time and scratch a shallow path along difficult lines before you cut them.

PRINTING THE LINOLEUM

You need to have three clean areas: one for printing, one for inking and one for placing your finished prints. Cut all your paper to the same size ahead of time. Don't forget to prepare some proof sheets, too! I'm printing this lino on a piece of *washi* paper. I like using a rubber-based ink because it dries slowly and I can clean it up with vegetable oil. You can also use a water-soluble oil-based ink that gives better results than the acrylic-based water soluble inks.

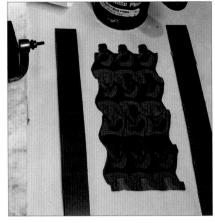

(15) **Printing setup.** So that the roller lays an even ink layer on the top of the lino, bearing strips cut from lino are used as roller guides. You can use the discarded lino from the sides of your image (as seen in step 13).

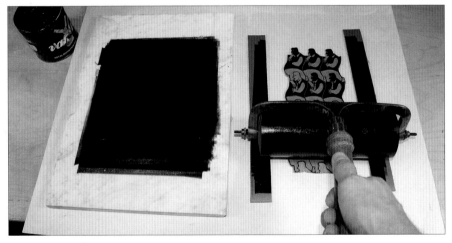

(16) **Ink the lino.** Here I've used a roller on a marble slab to roll out a thin layer of ink over the surface of the block. Notice how the bearing strips keep the roller level so that only the raised surface of the block is inked. You need to re-ink your block for each impression.

Tip

You can print on cloth or on a roll of paper

You can print on starched cloth with a fine weave such as linen or cotton. Starched cloth is easier to work with than unstarched material. With paper by the roll, the image can be repeated to create a long banner.

(17) **Place and burnish.** Place your lino on the paper, face down. Now gently slide your hand under the paper, flip it over and burnish the back as seen in Steps 19–22.

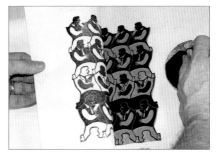

(18) **Peel back your print** after using a baren or a spoon to apply firm pressure over the entire surface. If some areas are not dark enough, and if you haven't removed the paper entirely, you can lay the paper down again and burnish some more.

(19) **Place your lino** onto the paper beside your first impression. Register your lino with the side of the first printed image. Press it down firmly, allowing the natural tack of the ink to hold the block in place.

(20) **Holding the lino** and carefully sliding your hand under the paper, flip the whole assembly over without shifting the block or paper. If your ink is not tacky, your paper will shift!

(21) **Rub the image** down to hold it in place. This method of registering the lino by eye doesn't require any guide marks or jigs. See page 113 for a picture of a printing jig.

(22) **Burnish your lino** from the back, with a sheet of newsprint between your printing paper and the baren. This will prevent the paper from pilling as you are rubbing.

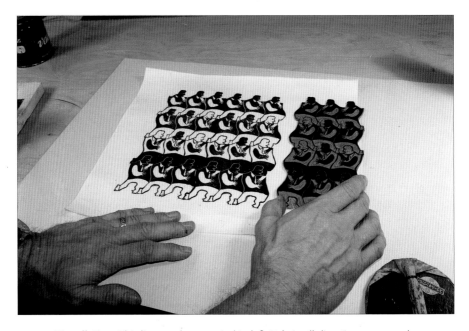

(23) STEP

Tessellating. This lino can be repeated indefinitely in all directions across a large sheet of paper or sheet of cloth. Tessellating an image is a fun way to create larger works using a pattern. The trick is to keep your hands and the paper clean as you work. This sounds easy, but it isn't because the ink tends to spread if you are not careful where to touch. I always try to handle the lino by the side edge and on an area where I haven't let the ink touch. The bearing strips help to keep the ink on the raised surface, leaving the lower areas dry to handle.

WHAT WAS USED TO MAKE THIS PRINT?

Materials & Tools

Materials:

Battleship linoleum – 4" x 9"
Household iron
Pencil, ruler, eraser, fine brush
Drawing ink, printer's ink
Washi paper
Vegetable oil or coconut-based esters
as solvent replacement, or mineral
spirits (to clean up the ink)

Tools:

Ink brayer
Baren for burnishing
Lino tools: gouge and parting tool
Mat knife
Pen X-acto knife
Ink knife
Bench hook

Tip

Use a cotton rag to clean up

A cotton rag is better and more absorbent than a paper towel for cleaning up ink. Scrape off as much ink as you can from your inking plate and use a small amount of solvent to wipe up the residue.

GLOSSARY

Artist's proof (A/P) A print that is pulled by the artist for his or her own use; not part of the regular edition.

Baren A disk-shaped Japanese burnishing tool.

Belly The two bottom sides of the graver in wood engraving, or the underside of the shank of a woodcut tool or engraving tool.

Bleed Printed area that exceeds the boundaries of the paper, or the quality of an ink to spread on an absorbent paper.

Bon à tirer Means "good to pull" and indicates that the print was used as the standard of the edition. All other prints in the edition were compared to it for quality and consistency.

Brayer A small hand roller used for inking blocks.

Burin *See* **Graver**.

Burnishing Providing pressure for printing to the back of the paper by rubbing it with a smooth instrument such as a baren or spoon.

Burr The rough edge or particle ridge found on tools, blocks and plates that occurs when sharpening or cutting.

Cancellation proof A proof pulled from a block that has been defaced to prove that the block can no longer be used to make impressions.

Cape boxwood A boxwood from South Africa that is also known as Kamassihout, Knysna boxwood or Kamassi boxwood. It is a good substitute for the more expensive English boxwood.

Chase A frame used to lock up blocks and type forms for printing.

Clearing Removing material that you do not want to print.

Cylinder press A press with a flat metal bed, which holds the block, and a roller that passes over the block, pressing paper and block together.

Deckle edge The irregular edge of a sheet of handmade paper.

Dotted print A print made entirely of white dots.

Driers Additives used to speed the drying of ink.

Durometer A unit, usually expressed as a number between 10 and 100, measuring the hardness or softness of a brayer.

Edition A series of prints that are all printed at the same time using the same blocks.

Elliptic tint tool *See* **Spitsticker.**

End-grain block A block cut from a cross section of a log, with the growth rings clearly visible.

Engraving *See* **Wood engraving.**

Estisol is a vegetable cleaning agent (VCA) that replaces solvents such as mineral spirits.

Extenders Ink additives used to improve the body of the ink and increase the volume of ink without lowering its viscosity.

Frisket A thin sheet of paper, cut out to expose the block, that is stretched over the tympan as a mask to keep the printing paper free of accidental smudges of ink.

Furniture The metal or wood blocks used to lock a block or lead type into a printing form so that it doesn't move or shift.

Gouge A woodcut tool with a concave cutting edge, used to carve white lines in wood blocks.

Grain The direction of fibers in wood that follow a single axis.

Graver The basic engraving tool, a fine steel rod with a square or diamond-shaped end blade; called a *burin* by metal engravers.

Hot pressed (HP) Describes a very smooth sheet of paper made by pressing the sheets between hot plates or rollers during its manufacture.

Impression The mark made by a block into the surface of a sheet of paper.

Kento marks Registration marks carved on the block for Japanese-style woodcuts.

Key block In multiple-block color printing, the master block that carries the black outline of the image and is used to register all subsequent blocks.

Laid paper Paper with parallel lines running across the sheet that are visible when the sheet is held to the light.

Letterpress The equipment and relief printing method for printing lead type and type-high blocks and plates.

Limited edition A series of prints in which a limit is placed on the number of impressions pulled, establishing the scarcity of the print. They are usually numbered and signed. Limited editions are a recent development, dating from the late 19th century.

Lining tool *See* **Multiple tool.**

Lino block A block made of linoleum.

Linocut An impression made from a lino block.

Make-ready The process of adjusting the printing pressure over specific areas of the block or leveling the block on the press.

Multiple tool A tool used to create multiple parallel lines with a single stroke; also called a *lining tool.*

Parting tool Also called a *V gouge*, this tool has two flat blades that meet at an apex. The tool blades resemble a letter V; hence, the alternate name.

Plank Wood cut along the length of the log, parallel to the grain.

Platen press A press with two cast metal plates that squeeze the block and paper together to make an impression.

Proofing The act of taking impressions from a block to see how the image is progressing and determine whether more cutting is necessary.

PVA Polyvinyl acetate; also known as white glue or carpenter's glue.

Quoin A mechanical device used to lock up and secure type or blocks in a chase or press bed.

Registration system The method used to align blocks so that they print in exactly the same place on the sheet for each impression.

Relief printing Any printing done from a raised surface.

Round graver *See* **Scorper.**

Sandbag A small leather cushion used to hold the block while it is being engraved. Also called an *engraver's cushion* or *engraver's pad.*

Scorper A tool used for clearing open areas and for making broad lines; also called a *round graver.*

Shank The long metal piece between the handle and the cutting edge of a woodcut tool.

Spitsticker A tool with convex sides used for cutting fine and curved lines; also called an *elliptic tint tool.*

164 ◆ THE WOODCUT ARTIST'S HANDBOOK

Tack The sticky quality of an ink that makes it adhere to the paper.

Tear bar A straight edge used to tear paper to give it the effect of a deckle edge.

Tint tools Tools used for engraving parallel lines of equal width to create tones or tints.

Trial proof A print taken before the art on the block is finished, to determine what further cutting needs to be done to the block.

Tympan The packing used on a press to adjust the pressure.

Type high The standard height for blocks and type to be printed on a letterpress; in the United States and Canada it is 0.918 inch.

Viscosity The degree to which an ink resists flowing and its resistance to spreading when under printing pressure.

U gouge *See* **Gouge**.

V gouge *See* **Parting tool**.

Watermark A mark (usually a logo or image) made in the paper during its manufacture.

White line Refers to the carved lines on a block that do not print.

Wood block A plank (side-grain) block used for woodcut.

Wood engraving A print that is made by carving on the end grain of the wood, using engravers' tools.

Wood engraving block An end-grain block used for wood engraving.

Woodcut An image carved on the flat side of a board, with the grain running the length of the plank.

BIBLIOGRAPHY

Many books have been printed on the subject of woodcut and wood engraving, but unfortunately most of them are out of print. However, many antiquarian booksellers list their books on the Internet. Websites such as Advanced Book Exchange (www.abebooks.com) and university and college book-exchange sites are great places to find that rare wood-engraving book. Here are some books that you might want to consider for your collection.

TECHNICAL

Bedoyere, Camilla de la. *The Science of a Piece of Paper.* Gareth Stevens Publishing, 2009.

Beedham, R.J. *Wood Engraving.* London: Ditchling Press, 1921. With an Introduction and Appendix by Eric Gill. Reprinted London: Faber, 1948.

Biggs, John R. *Classic Woodcut Art and Engraving: An International Collection and Practical Handbook.* New York: Blandford Press, 1958.

Brett, Simon. *Wood Engraving: How to Do It.* Primrose Hill Press, 2000. A good practical how-to on wood engraving.

Chamberlain, Walter. *The Thames and Hudson Manual of Woodcut Printmaking and Related Techniques.* London: Thames and Hudson, 1978.

Chatto, William Andrew. *A Treatise on Wood Engraving, Historical and Practical.* With 300 engravings by John Jackson. London: Charles Knight & Co., 1839. This is the definitive early study on wood engraving.

Cleeton, Glen U. and Charles W. Pitkin. *General Printing: An Illustrated Guide to Letterpress Printing.* Reissue, Liber Apertus Press, 2006.

Henry, Frank S. *Printing for School and Shop: A Textbook for Printers' Apprentices Continuation Classes, and for General Use in Schools.* New York: John Wiley and Sons, 1944.

Jacobi, Charles Thomas. *The Printers' Handbook of Trade Recipes, Hints & Suggestions Relating to Letterpress and Lithography.* BiblioLife, 2009.

Kent, Rockwell. *How I Make a Wood Cut.* Pasadena, CA: Esto Publishing, 1934.

Lange, Gerald. *Printing Digital Type on the Hand-Operated Flatbed Cylinder Press.* Marina del Rey, CA: Bieler Press, 2001.

Maravelas, Paul. *Letterpress Printing: A Manual for Modern Fine Press Printers.*

Oak Knoll Press, 2005.

Moser, Barry. *Wood Engraving: Notes on the Craft.* West Hatfield, MA: Penny-royal Press, 1979.

Rothenstein, Michael. *Relief Printing.* New York: Watson-Guptill, 1970.

Ryder, John. *Printing for Pleasure.* London: Phoenix House, 1955. Reprinted Chicago: Henry Regnery, 1977.

Sander, David. *Wood Engraving: A Complete Guide.* New York: Viking, 1978.

Salter, Rebecca. *Japanese Woodblock Printing.* Honolulu: University of Hawaii Press, 2001.

REFERENCE

Ainslie, Patricia. *Images of the Land: Canadian Block Prints 1919–1945.* Calgary, AB: Glenbow Museum, 1984.

Bliss, Douglas Percy. *A History of Wood-Engraving.* New York: J.M. Dent & Sons, 1928. Reprinted London: Spring Books, 1964.

Brender à Brandis, Gerard. *Wood, Ink & Paper.* Erin, ON: The Porcupine's Quill, 1980.

———— and Danuta Kamocki. *The White Line: Wood Engraving in Canada Since 1945.* Erin, ON: The Porcupine's Quill, 1990.

Bates, Wesley W. *The Point of the Graver.* Erin, ON: The Porcupine's Quill, 1994.

Beronä, David A. *Wordless Books: The Original Graphic Novels:* Harry N. Abrams, 2008.

Durer, Albrecht. *Complete Woodcuts of Albrecht Durer.* Peter Smith, 1963.

Eichenberg, Fritz. *The Wood and the Graver.* Illustrated by Fritz Eichenberg. New York: Clarkson N. Potter, 1977.

Elsted, Crispin and Jan Elsted. *Endgrain. Contemporary Wood Engraving in North America.* Mission, BC: Barbarian Press, 1994. Printed in a limited edition of 430 copies.

Fern, Alan and Judith O'Sullivan. *The Complete Prints of Leonard Baskin.* Boston: Little, Brown, 1984.

Frasconi, Antonio. *Frasconi: Against the Grain : The Woodcuts of Antonio Frasconi:* Macmillan Pub Co, 1975.

Garrett, Albert. *A History of British Wood Engraving.* Atlantic Highlands, NJ: Humanities Press, 1978.

Gill, Evan. *Eric Gill, A Bibliography.* Revised by D. Steven Corey and Julia MacKenzie. Detroit: Omnigraphics, 1991.

Goldman, Judith. *Frankenthaler: The Woodcuts.* First ed., George Braziller, 2002.

Hind, Arthur M. *An Introduction to a History of Woodcut with a Detailed Survey of Work Done in the Fifteenth Century.* 2 vols. London: Houghton Mifflin, 1935. Reprinted New York: Dover, 1963.

Hubbard, Harlan. *The Woodcuts of Harlan Hubbard.* Scholarly Book Services Inc, 2002.

Jaffe, Patricia. *Women Engravers.* London: Virago, 1988. This book covers women pioneers in the field of wood engraving and woodcut.

Masereel, Frans. *Die Passion eines Menschen.* Munich: Kurt Wolff, 1928.

———. *Mein Stundenbuch.* With an introduction by Thomas Mann. Munich: Kurt Wolff, 1928. Text in German.

———. *Landschaften und Stimmungen.* Munich: Kurt Wolff, 1925. Reprinted and translated as *Landscapes and Voices.* New York: Schocken Books, 1988.

McCurdy, Michael. *Toward the Light: Wood Engravings of Michael McCurdy.* Erin, ON: The Porcupine's Quill, 1982.

Mueller, Hans Alexander. *Woodcuts and Wood Engravings: How I Make Them.* New York: Pynson Printers, 1939. Contains 300 illustrations and includes progressive stages in printing a color engraving, sample book pages, series of prints for illustrated books and techniques.

Polk, Ralph W. *Elementary Platen Presswork,* The Manual Arts Press, 1931.

Salaman, Malcolm C. *The Art of the Woodcut: Masterworks from the 1920s.* Dover Publications, 2010.

Sen, Sudeep. *South African Woodcut:* Peepal Tree Press Ltd, 1995.

Shapiro, Barbara Stern. *From Paris to Provincetown: Blanche Lazzell and the Color Woodcut.* Illustrated edition, MFA Publications, 2002.

Ward, Lynd. *Storyteller Without Words: The Wood Engravings of Lynd Ward.* New York: Abrams, 1974.

———. *Gods' Man: A Novel in Woodcuts.* New York: Jonathan Cape, 1929.

———. *Madman's Drum: A Novel in Woodcuts.* New York: Jonathan Cape, 1930.

———. *Wild Pilgrimage: A Novel in Woodcuts.* New York: Jonathan Cape, 1932.

Walker, George. *Graphic Witness: Four Wordless Graphic Novels by Frans Masereel, Lynd Ward, Giacomo Patri and Laurence Hyde:* Firefly Books, Richmond Hill, ON 2007.

Woodberry, George E. *History of Wood-Engraving.* New York: Harper & Brothers, 1883.

ARTIST BIOGRAPHIES

Suezan Aikins (1952–) and Sam Rogers (1952–) live and work by the sea in Nova Scotia. A retrospective of their atmospheric original woodblock prints has toured Japan and, most recently, Germany, where the 25th anniversary of their unique collaboration was celebrated. www.suezan-aikins.com

Walter Bachinski (1939–) attended the Ontario College of Art in Toronto and received a Master's degree in printmaking at the University of Iowa in 1967. He taught drawing and printmaking at the University of Guelph and has exhibited widely since the early 70s. In 1966, with Janis Butler, he established Shanty Bay Press to publish books in the *livre d'artiste* tradition.

Peter Barron (1943–) studied printmaking and drawing at the Ontario College of Art. He received his BA (fine art) from the University of Guelph in 1974. Since then he has worked as a painter, sculptor, printmaker and teacher.

Leonard Baskin (1922–2000) studied at Yale University from 1941 to 1943 and received his BA at the New School for Social Research in 1949. Baskin also studied art in Paris and Florence. In 1953 he began teaching printmaking and sculpture at Smith College in Northampton, Massachusetts, where he remained until 1974.

Wesley W. Bates (1952–) was born in Yukon and raised in southwestern Saskatchewan. He moved to Hamilton in 1977 after leaving Mount Allison University. Bates pursued a career as a painter and printmaker and took up wood engraving in 1981. He established West Meadow Press in 1983.

William Blake (1757–1827), English poet, painter and engraver, was born in London, England. He attended school only long enough to learn to read and write. Blake's father recognized his son's talent for drawing and apprenticed him to an engraver. He married Catherine Boucher, who helped make his unique books by coloring his prints and bookbinding their small editions.

Gerard Brender à Brandis (1942–) was born in the Netherlands and immigrated to Canada in 1947. He holds a BA in fine arts history from McMaster University. From 1969 to 1985 he published handmade books under the imprint of the Brandstead Press, and, since moving to Stratford, Ontario continues producing one-of-a-kind books and limited editions as well as single-leaf wood engravings and linocuts.

Simon Brett (1943–) went to St. Martin's School of Art, where he learned wood engraving from Clifford Webb. Until 1980 his work as a wood engraver was largely ephemeral, but since then he has illustrated several books and published many of them under the Paulinus Press imprint. www.merivaleeditions.com/merivaleprints/brett_beast.html

Deborah Mae Broad (1955–) is a professor of printmaking at Minnesota State University, Moorhead. She received her MFA in printmaking in 1980 from the University of Tennessee in Knoxville. www.deborahmaebroad.com

Janice Carbert (1959–) holds a BFA from the Nova Scotia College of Art and Design and has lived and worked in Toronto since 1985. She was a founding member of the Red Head Gallery and has had exhibitions at Open Studio (Toronto) and Lyndia Terre Gallery (Alton). She is represented by Open Studio. www.openstudio.on.ca

Franklin Carmichael (1890–1945) was a prominent landscape artist and was an original member of Canada's Group of Seven. He was born in Orillia, Ontario. He studied at the Ontario College of Art in Toronto and later taught there from 1932 to 1945. His printing press is still used in the college's printmaking studio.

Osvaldo Castillo (1978–) is a Montreal-based print media artist. His narrative focuses on the social, cultural and political landscape of El Salvador's history filtered through personal memory and dreams. www.artroot.com/artists/osvaldo/gallery1/pages/slide-4_jpg.htm

Guy Debenham (1923–2002) was born in 1923 in Scarborough, England. After qualifying as a surgeon, he immigrated to Canada where he practiced for over 30 years. His love of wood engraving was encouraged by his correspondence with Reynolds Stone, George Mackley and T.S. Lawrence and Sons. He is known for his bookplates and his many engravings of the Canadian landscape.

Albrecht Dürer (1471–1528) was a German Renaissance painter and printmaker born in Nuremberg. He worked with Michael Wolgemut, who introduced him to woodcut and provided him with commercial work for his woodcut illustrations. He is one of the most important woodcut artists and his work continues to inspire artists today.

Stephen Fakiyesi (1969–) was born in Nigeria and immigrated to Canada in 1975. He received an MFA from the University of California in Los Angeles. He lives in Toronto.

Elizabeth Forrest (1947–) was born in Vancouver. She studied art at the Ontario College of Art, where she subsequently worked as an instructor in the printmaking department. She has exhibited nationally in both public and private galleries. In 1988, she traveled to Japan to study Japanese woodblock printmaking, later exhibiting her work in Kyoto, Osaka and Tokyo. www.lizforrest.com

Paul Gauguin (1848–1903) was one of the most prominent French painters of the Post Impressionist period. In 1891 he left France for the South Pacific and Tahiti, where he was inspired to make woodcuts.

Eric Gill (1882–1940), sculptor and master of wood engraving and woodcut printing, was also a famous designer of typefaces. Born in Brighton, England, he served his apprenticeship to an architect in London until he met Edward Johnston, who introduced him to the Arts and Crafts movement. He authored books on social reform and the importance of the working man. Gill Sans is his most famous typeface.

Holly Greenberg (1967–) received her BFA in studio arts from the University of Michigan (1989) and her MFA in printmaking from the School of the Art Institute of Chicago (1994). She is an assistant professor of printmaking at Syracuse University, New York. She has twice received the Frans Masereel Fellowship for printmaking.

Julius Griffith (1912–1997) was born in Vancouver. He studied art at the Slade School and the Royal College of Art in England and with Fred Varley of Canada's Group of Seven. In 1940 he was a sublieutenant in the British Navy stationed in Russia. He met his wife Lialia in England and, after the war, they settled in Canada. Some of my fondest memories are of visits to their home, chatting about art over afternoon tea.

Fred Hagan (1918–2004) was born in Toronto and studied art at the Ontario College of Art. Under the tutelage of Franklin Carmichael, Hagan developed his interest in printmaking and painting. He became well known for his prints and paintings depicting social injustice and the complexities of the human condition.

Jim Horton (1947–) printmaker, wood engraver, with four decades of teaching art. He is an avid student of historical engraving and letterpress processes. Jim is a member of the Wood Engravers' Network (WEN).

Paul Hunter (1965–) and Leah Springate (1966–) are a husband and wife artist/writer team from Toronto. They run Mammoth Hall Press. Their handprinted books and art are highly prized among collectors. www.geocities.com/mammoth_hall_common/mhc_tulseluper

Christopher Hutsul (1977–) is a Toronto-based artist, illustrator and writer. After studying printmaking at the Ontario College of Art and Design, he worked as a cartoonist and illustrator and later became a staff writer at the Toronto *Star*. He continues to depict urban settings through relief printing. www.hutsul.com

Brian Kelley (1946–) studied art in New York, graduating from Pratt Institute in 1968. He traveled to Europe and North Africa before emigrating to Canada in 1970. In 1980 he went to Japan to study woodcut printing under Toshi Yoshida. In 1990 Kelley traveled to China with an exhibition of Canadian prints from Open Studio artists. In 1997 he was a guest artist at Cape Dorset on Baffin Island.

Käthe Kollwitz (1867–1945) was born in Königsberg and studied art at the School for Women Artists in Berlin. She married a physician who practised in one of the poorer districts of Berlin, where she witnessed much suffering. They lost their son in World War I. Her work centered around the suffering of the lower classes, and she developed strong socialist ideals that emerged in her printmaking.

Lisa Levitt (1953– 2009) graduated with a Fine Arts diploma from Fanshawe College, London, Ontario in 1973. She made her living as a graphic designer before returning to printmaking full-time in 1996. She has exhibited internationally from Lima, Peru, to Kochi, Japan, and currently makes her home in Toronto.

Margaret Lock (1950–) was born in Hamilton, Ontario, and graduated with an honors BFA from McMaster University in 1972. She and her husband Fred founded Locks' Press in 1979. Most of the books, pamphlets and broadsides published by the press are illustrated with Margaret's woodcuts.

Frans Masereel (1889–1972) was born in Belgium. Although he came from an upper-class family he had strong socialist views, which he expressed in his woodcut novels. When World War I broke out he fled to Geneva, where he met many left-wing artists and writers who would become his lifelong friends. His illustrations for the pacifist magazines *Les Tablettes* and *La Feuille* established his international reputation.

Naoko Matsubara (1937–) is one of the foremost woodcut artists in the world. She grew up in Kyoto, where her father was a Shinto priest. After graduating from Kyoto City College of Fine Arts, she was a Fulbright Scholar at Carnegie Institute of Technology and later studied at the Royal College of Art. Her work has been exhibited internationally and is in public and private collections throughout the world. She works and lives in Oakville, Ontario.

Michael McCurdy (1942–) attended the School of the Museum of Fine Arts in Boston. He graduated from Tufts University in Massachusetts. He has taught at the School of the Museum of Fine Arts in Boston, the Concord Academy and Wellesley College Library's Book Arts Program. He has exhibited internationally and has over 200 book illustrations to his credit. www.bcn.net/~mmccurdy

Sharon Merkur (1932–2002) was born in Toronto, and graduated from the Ontario College of Art in 1973, where she studied with Fred Hagan. In 1991 she had a solo exhibition at the Bar Am Museum in Israel. She is best remembered for her vivid woodcut impressions of the landscapes of Israel.

William Morris (1834–1896) was born in England to a wealthy family. He studied at Oxford, where he became interested in art and socialism. He founded the famous Kelmscott Press in 1890. He loved the care taken in the making of 15th-century books and wanted to revive the tradition in his own publications.

Barry Moser (1940–) is a master wood engraver. He was educated at the University of Tennessee and the University of Massachusetts. He has designed and illustrated over 250 books. As well as being one of the best wood engravers in North America, he is considered one of the finest book designers. He teaches in the faculty of art at Smith College, Massachusetts.

David Moyer (1952–) received a BFA in Ceramic Sculpture from the University of Delaware and became interested in printmaking. Since 1988, Moyer and his partner Gretchen have been publishing their art under the name Red Howler Press. www.forumbookart.com/vorzugs/vorpag/vor6N

Lisa Neighbour (1957–) attended the Ontario College of Art, where she studied printmaking and graduated in 1981. In 2004 she showed her work at Katherine Mulherin Contemporary Art Projects, Toronto, and in 2005 had a showing at the Canadian Cultural Centre in Paris, France .

Nigel Nolan (1980–) is a visual artist working predominantly in large-scale relief printing, drawing and installation. He lives in Toronto. www.nigelnolan.com

Mary Paisley (1945–1994) was born in Nashville, Tennessee. A socially and politically engaged artist whose work addressed the interrelationship between history and memory, she experimented with batik, relief printing, intaglio, installations, drawing, acrylic and oil painting, lithography and handbound artist's books.

Olga Philip (1939–) was born in Simcoe, Ontario, and studied under Fred Hagan at the Ontario College of Art. After graduation she focused on relief printing and papermaking. Her relief printing is featured in many anthologies.

Chet Phillips (1956–) presents his slightly off-center view of the world through his digital illustration. In 1979, he ventured into the world of commercial illustration. His traditional tools were replaced by a computer in the early 90s. The software Painter™ became his primary tool for creating digital woodcuts and scratchboard for advertising, design, publishing and corporate clients. www.chetart.com

José Guadalupe Posada (1852–1913) was born in Mexico and is one of the most influential Mexican graphic artists of the 20th century. His engravings were published in Mexico City newspapers, where they reached a wide audience. Although he died poor and largely unrecognized, his political, social and moral themes using skeletons as metaphors are highly prized today for their expressive style and wit. muertos.palomar.edu/posdad.htm

William Rueter (1940–) was born in Kitchener, Ontario, and studied at the City Literary Institute, London, England, and the Ontario College of Art. He is a private printer, hand-binder and printmaker living in Dundas, Ontario. His work has been shown throughout North America and in Japan. He has taught graphic design in Canada, Barbados and the Philippines.

Ralph Steadman (1936–) started as a cartoonist and diversified into many fields. He has illustrated such classics as *Alice in Wonderland* and *Treasure Island*. His own books include the lives of Freud and da Vinci. With American writer Hunter S. Thompson he collaborated in the birth of gonzo journalism with *Fear and Loathing in Las Vegas*. He is a printmaker whose works include a series of etchings on writers from William Shakespeare to William Burroughs. www.ralphsteadman.com

Alan Stein (1951–) is a painter, printer and wood engraver. He established the Church Street Press in 1988 and designs, hand-prints and illustrates his own limited-edition books. He has exhibited his watercolors and drawings widely and is represented in Toronto by the Roberts Gallery. www.robertsgallery.net

Jeannie Thib (1955–) was born in North Bay, Ontario, and received a BFA from York University, Toronto. She has exhibited widely across Canada and created permanent public artworks for places including the Japanese Canadian Cultural Centre in Toronto and the Esplanade in Medicine Hat, Alberta. She is represented by Leo Kamen Gallery, Toronto. www.ccca.ca

Adam Thyssen (1978–) was born in St. Thomas, Ontario, and received a BFA from the Ontario College of Art and Design. His work can be found in collections around the world, including the National Library in Ottawa.

Frederica Tomas (1962–) was born in Toronto. She studied at the Ontario College of Art and Design, where she focused on printmaking. After graduation she started Utility Grade to distribute her handmade prints and limited-edition books. Her work is in the collection of the Victoria and Albert Museum, as well as many private and corporate collections around the world.

George Walker (1960–) was born in Brantford, Ontario, and graduated with honors from the Ontario College of Art, and later from Brock University, York University and Ryerson Universtiy. He is currently an associate professor of printmaking at the Ontario College of Art and Design. He was elected to the Royal Canadian Academy of Arts (RCA) in 2002 in recognition of his achievements in the book arts. www.george-walker.com

Lynd Ward (1905–1985) was born in Chicago and studied art at Columbia University in New York. He left the United States to study art at the Leipzig Academy for Graphic Arts where he learned wood engraving from Hans Alexander Mueller. The work of Frans Masereel and Otto Nuckel inspired his interest in the wordless novel. His most famous wordless novels are *Gods' Man* and *Madman's Drum*.

Jim Westergard (1939–) received his MFA from Utah State University. He moved to Canada in 1975 and taught printmaking at Red Deer College until his retirement in 1999. His wood engravings are celebrated internationally for their whimsical noir character. www.telusplanet.net/public/jimwest

RESOURCES AND ORGANIZATIONS

Below is a list of organizations, resources and suppliers to help you get started. Joining an organization can be a great way to meet new people who share the same interests. These organizations will keep you informed of upcoming exhibitions, workshops and events. If you can't find what you're looking for at your local art supply store, try the Internet. It's an amazing resource for finding supplies.

Baren Forum
This is an online forum for woodcut printmakers. If you can't find the information you need in this book, this site is the next place to check. www.barenforum.org

The Canadian Bookbinders and Book Artists Guild
CBBAG (pronounced "cabbage") was founded in 1983. It publishes a quarterly newsletter and organizes exhibitions and workshops as well as having a fabulous website. www.cbbag.ca

Endgrain Editions
This press specializes in publishing books about wood engraving. www.barbarianpress.com

The Society of Wood Engravers
PO Box 355, Richmond, Surrey, UK TW10 6LE
Founded in 1920. It organizes exhibitions and offers educational information through its website. Its newsletter is published six times a year. www.woodengravers.co.uk

Wood Engravers' Network
It publishes a quarterly newsletter called *Block & Burin*.
The organization also has a forum for the exchange of prints, called
"The Bundle." www.woodengravers.net

WEBSITES ABOUT PRINTS AND PRINTMAKING

www.printalliance.org
The American Print Alliance website features members' work.

www.artshow.com/resources/printmaking.html
Art Show - Links to printmaking demonstrations.

www.sharecom.ca/phillips/technique.html
The Technique of the Color Woodcut by Walter J. Phillips. An online
version of this classic book.

www3.sympatico.ca/george.walker
This is my website featuring my wood engravings, artist's books and
links to other great sites.

www.worldprintmakers.com
This site features contemporary printmakers from around the world.

SUPPLIERS

Aboveground Art Supplies
74 McCaul St., Toronto, ON. Canada M5T 2K1
www.abovegroundartsupplies.com
Stocks water-soluble ink, oil-based ink, tools, paper and brayers.

Baren Mall
http://barenforum.org/mall/howtoshop.html
This is a non profit service for woodcut artists who want to buy materials
and equipment from Japanese suppliers who do not ship outside of Japan.

Chris Daunt
1 Monkridge Gardens, Dunston, Gateshead, England NE11 9XE
Makes and supplies fine end-grain wood engraving blocks.
http://chrisdaunt.com/

Don Black Linecasting Ltd.
120 Midwest Rd. Unit 5, Scarborough, ON. Canada M1P 3B2
www.donblack.ca
Sells presses, brayers, lead type, wood type and letterpress supplies.

Daniel Smith Inc.
Seattle, WA. United States 98124-5568
customer.service@danielsmith.com, www.danielsmith.com
Stocks a wide assortment of relief printmaking supplies and water-soluble oil-based ink.

E.C. Lyons Company
3646 White Plains Rd., Bronx, NY. United States 10467
www.eclyons.com
Sells wood-engraving tools.

Exotic Woods Inc.
2483 Industrial St., Burlington, ON. Canada L7P 1A6
www.exotic-woods.com
Sells wood: boxwood, maple and exotics.

Graphic Chemical and Ink Company
728 North Yale Avenue, P.O. Box 27, Villa Park, IL. United States 60181
http://www.graphicchemical.com
Has a large selection of printmaking supplies.

Hiromi Paper International
2525 Michigan Ave., Beramot Station G9, Santa Monica, CA.
United States 90404
www.hiromipaper.com
Stocks a large selection of *washi* paper.

The Japanese Paper Place
77 Brock Ave., Toronto, ON. Canada M6K 2L3
www.japanesepaperplace.com
The best source for printing papers, paste, barens and brushes
for Japanese block printing.

John Purcell Paper
15 Rumsey Road, London, England SE1 1SG
www.johnpurcell.net
Stocks printmaking papers.

Lee Valley Tools Ltd.
http://www.leevalley.com
Stocks a large selection of woodcut tools.

McClain's Printmaking Supplies
15685 SW 116th Ave., PMB 202, King City, OR. United States 97224-2695
www.imcclains.com
Stocks a wide range of printmaking supplies.

Rembrandt Graphic Arts
PO Box 130, Rosemont, NJ. United States 08556
sales@rembrandtgraphicarts.com
Sells printmaker's materials, and has a large selection of printmaking
supplies.

Renaissance Graphic Arts, Inc.
69 Steamwhistle Drive, Ivyland PA. United States 18974
www.printmaking-materials.com
Has a large selection of printmaking supplies.

Righteous Woods
Yankee Pine Corporation, 288 Newburyport Turnpike (RTE 1),
Rowley, MA. United States 01969
www.righteouswoods.net
Sells boxwood logs and exotic woods.

Saint-Armand Paper Mill
3700, rue Saint-Patrick, Montreal, QC. Canada P4E 1A2
www.st-armand.com
Sells handmade paper.

T.N. Lawrence and Son Ltd.
208 Portland Road, Hove, United Kingdom BN3 5QT
www.lawrence.co.uk
Fortunately, the oldest supplier is still in business. T.N. Lawrence
and Son Ltd. have been supplying boxwood since 1859.

INDEX

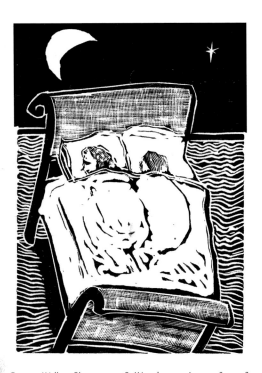

George Walker. *Sleepers*. 1998. Wood engraving; 2.5" x 3.5"